LEWIS & CLARK

HANDS ON

ART & ENGLISH ACTIVITIES

by Sharon Jeffus

Lewis & Clark Hands On by Sharon Jeffus

Published by Geography Matters

Cover design and layout by Alex Wiggers

Originally published by Visual Manna, copyright © 2003 by Sharon Jeffus. Previous ISBN 0-9715970-5-7

Copyright ©2009 Geography Matters, Inc. All Rights Reserved.

ISBN: 978-1-931397-59-9
Library of Congress Control Number: 2009921418

Printed in the United States of America

Geography Matters
800-426-4650
www.geomatters.com

Acknowledgements and Credits

I would like to thank Dr. Wayne Bertz for his encouragement and wisdom.

Thanks to Linda Fowler for her input on this completely revised version.

Credit is given to Dover Pictorial Archives, the late Richard Jeffus, Sharon Jeffus, Michael Helm, and Kathy Wright for artwork.

Credit is given to Josh Wiggers for the maps.

Table of Contents

Dedication

This book is dedicated to Anthony Harris and Susan Harris.

These two people have been dramatic lights for the kingdom of Christ.

Thank you for what you have meant in my life
and in the lives of so many others.

*"The righteous cry out, and the Lord hears them and delivers them
from all their troubles."* *Psalm 34:17*

The Lewis & Clark Expedition

You are about to begin studying one of the greatest adventures in American history, through hands-on art activities and personal journaling. The adventure: The Lewis and Clark Expedition.

President Thomas Jefferson was a **visionary** president who was fascinated with the territory west of the Mississippi River. He arranged for the United States to pay France $15 million dollars for 800,000 square miles located in the middle and northwestern parts of what is now the United States. This was called the Louisiana Purchase and it is the largest land **acquisition** in American history. President Jefferson commissioned Meriwether Lewis to organize an expedition to explore a portion of this land. They hoped to find a water route that would link the Atlantic Ocean and the Pacific Ocean.

Here is a quote from Thomas Jefferson's instructions to Meriwether Lewis:

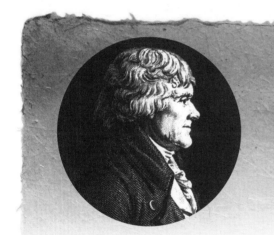

" The object of your mission is to explore the Missouri River and such principal stream of it, as, by its course and communication with the waters of the Pacific Ocean, whether the Columbia, Oregon, Colorado or any other river may offer the most direct and practicable communication across this continent and for the purpose of commerce...."

– Thomas Jefferson

Because President Jefferson had so much confidence in Lewis, he appointed him leader of the expedition and allowed him to choose a second in command. If you were named for a great journey of exploration, who would you choose to travel with you?

Meriwether Lewis chose William Clark to join him in this great adventure, and they selected other men to help them explore this vast territory. This group, known as The Corps of Discovery, consisted of 48 men including Lewis and Clark, one woman, and one child. They set out on May 14, 1804, from St. Charles, Missouri. A large keelboat and several smaller boats were used to carry the members of the Corps and a large amount of supplies on the first leg of their journey. They reached the Pacific Ocean in November of 1805. Although they were disappointed to learn there was no water route linking the two oceans, they did accomplish the greatest parts of their mission—exploring and mapping the northwest territory. In the same way that the astronauts are our heroes today, explorers of the west were the heroes of that time period.

Arriving back home on September 23, 1806, their exploration took nearly two years to complete. Think about what you were doing two years ago, and then imagine being on a journey lasting that long.

Preparation for the Journey

Explorers need to be prepared for their journeys. Some things they learn from experiences in their lives. Others must be studied before leaving on an adventure. Meriwether Lewis learned from his mother while growing up and, as an adult, from two very interesting individuals, Benjamin Barton and Andrew Ellicott.

Benjamin Barton

Benjamin Barton was invaluable to the success of the Corps of Discovery. He was a scientist who published the first textbook on **botany** in the United States. Even though Lewis' mother had taught him a great deal about nature, before setting out on the expedition he spent time with Barton to learn even more. Barton taught him how to preserve plant, bird, and animal specimens, and about the importance of properly labeling everything he collected. One of the most important things he taught Lewis was how to use the Linnaean system for classifying specimens using Latin

In this pictures the black is **negative space** and the white is **positive space**.

names. All this came in very handy, because when Lewis returned from his journey into the northwest he brought back specimens of an amazing 226 new plants, painstakingly collected, labeled, dried, stored, and transported. They can all be seen today at the Lewis and Clark Herbarium at the Academy of Natural Sciences in Philadelphia, Pennsylvania.

Andrew Ellicott

When Meriwether Lewis needed to learn celestial observation to help map his journey, he went to Andrew Ellicott. Ellicott was America's foremost surveyor and an accomplished mathematician. He had already conducted several large surveys that established state and territorial boundaries, including the boundary between the United States and Spanish possessions in Florida. In 1791 President Washington asked him to survey the bounds of the District of Columbia, and in 1803 he published *The Journal of Andrew Ellicott*. This book mapped the mouth of the Mississippi River and also accurately fixed the position of the mouth of the Missouri River. Ellicott was a strong supporter of the Louisiana Purchase. This naturally led him to be enthusiastic toward Lewis, who later wrote that he found Ellicott to be "extremely friendly and attentive." Ellicott taught Lewis how to use a sextant, octant, chronometer, and other surveying equipment during Lewis' nearly three-week visit.

Draw a starry sky at night.

Think about what Lewis and Clark might have seen in the sky on a starry night. Draw on black paper using white chalk for stars.

Journaling

One of the most exciting things about the Lewis and Clark Expedition is reading the wonderful journals that were produced. The journals describe what the early American wilderness was really like. Several men on the expedition contributed to the journals and many kept their own personal journals.

You may notice as you read the different excerpts in this book that the grammar and spelling was poor and inconsistent by today's standards. Selected passages from their journal entries are included throughout this book in their pure form. No attempt is made to correct them, yet you can still understand what they communicated. Notice how the following passage gives readers a feel for the geography of the area.

May 22, Wednesday 1805

The wind continued to blow so violently hard we did not think it prudent to set out untill it luled a little, about 10 oClock we set out the morning cold, Capt Lewis walked out before dinner & killed a Deer, I walked out after dinner and assended a But[te] a few miles [off] to view the countrey, which I found roleing & of a verry rich stickey soil producing but little vegetation of any kind except the prickley pear, but little grass & that verry low, a great deal of scattering Pine on the Lard Side & Some few on the Stard. Sd. Game not so abundant as below, the river continues about the same width, fewer Sand bars & current more regular, river falls about an inch a day

We camped on the Stard. Side, earlier than we intend on account of saveing the oil of a bear which the party killed late this afternoon.

Many of the Creeks which appear to have no water near ther mounths have streams of running water higher up which rise & waste in the sand or gravel. the water of those creeks are so much impregnated with the salt substance that it cannot be Drank with pleasure.

— John Ordway

Monday May 14, 15 1804

Rained the fore part of the day. I determined to go as far as St. Charles a french Village 7 Leags up the Missourie, and wait at that place until Capt. Lewis could finish the business in which he was obliged to attend to at St. Louis and join me by Land from that place 24 miles...at 9 o'clock Set out and proceeded on 9 miles passed two Islands and inclamped on the Starbd. Side at a Mr. Pipers Landing opposet an Island, the Boat run on Logs three times to day, owing her being too heavy loaded a Sturn, a fair afternoon, I saw a number of Goslings today on the Shore, the water excessively rapid and the Banks falling in.

- Clark

Keep a journal while using this book.

Some of the greatest minds in history have kept a journal or sketchbook, like Thomas Edison, Marco Polo, and Leonardo da Vinci and others. Record your thoughts every day and do the activities and drawings assigned. If you can, use a journal with half blank paper and half lined paper on each page. If this is not possible, journal in a sketchbook. Use an ebony drawing pencil for your sketches. Journals and drawing pencils can be obtained through VisualManna.com or at most art supply stores.

When you write your journal entries, first focus on writing your thoughts and ideas, not spelling and grammar. After you have communicated your thoughts, ask your teacher or parent to show you any spelling or grammar errors. You can learn to spell the words you missed on your own or add to your weekly spelling list.

Quill Pens

President Jefferson used a feather pen for all formal writing. This was a common practice at that time in history.

In early America, school children used pens made from small, carved twigs or feathers. Pens made from twigs were called "wood **nib** pens," but feather pens were better for writing.

Have you ever found a feather on the ground? Birds lose their feathers a few at a time from both sides of the body so they stay evenly balanced. There are two kinds of feathers; contour and down. Contour feathers are found on the wings, tail, and body of the bird. The strands, or barbs, of the feather lock together. Down feathers are fluffy and used for warmth. Quill pens are made of the contour feathers.

Making a Quill Pen

Materials:
contour feather (found outside or obtained from art or craft store)
acrylic paints
small brushes

1. Cut the end of the feather quill diagonally. Trim the edges into a point.

2. Paint a picture or design on your feather.

3. Dip the pen in ink made with berries (recipe below) and write in your journal.

Berry Ink
1/2 cup ripe berries
1/2 tsp salt
1/2 tsp vinegar

Mash and strain the berries and throw the pulp away. Add salt and vinegar. Stir.

Meriwether Lewis

Meriwether Lewis had experience as a woodsman and a soldier. He loved science and exploring new places. Early America was the perfect place for him. He became the private secretary to Thomas Jefferson and helped him plan the details of a western exploration expedition, and in 1803, Congress authorized the project. Because of his interest in natural science, which is a combination of **botany** and **zoology**, Lewis became the expedition's **naturalist**. He used his keen observation skills to make detailed notes about plants and animals. After Meriwether Lewis returned from this exciting exploration, he was appointed the first governor over the Louisiana territory. Can you think of any reasons why he might have been the best man for the job?

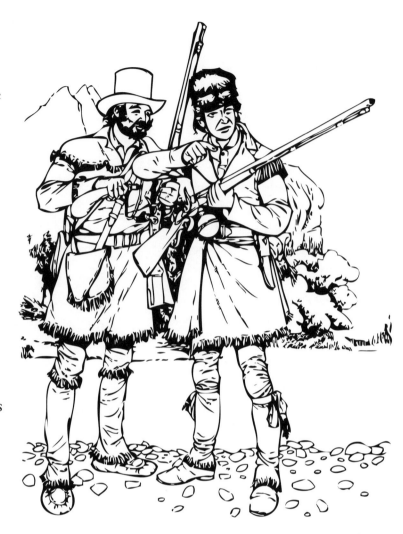

William Clark

William Clark was the man Lewis chose to join him on the expedition. Even though he was technically second in command, the men in the Corps of Discovery never knew it. In fact, Lewis and Clark shared leadership equally and were both known by the title of "Captain."

Clark spent many years as an infantry officer in the army, and the two men met when Lewis served in his rifle company. Clark was known for his courage and leadership, which made him an excellent choice for the journey. In addition, he had learned to draw maps during his time in the army. Because of that, and because of his many years of experience on the frontier, Clark was prepared for the important task of being mapmaker for the expedition. His time in the army also helped him develop **negotiation** and **diplomacy** skills, which were useful when they met Native Americans.

Write short character sketches about Lewis & Clark.

You might want to find out a little more about these explorers at the library or, with your parent's permission, on the Internet before you begin. Try to include inner qualities, as well as physical descriptions, in each **character sketch**.

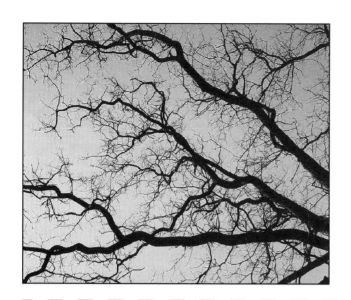

Amazing Discoveries

Lewis kept a journal for the entire trip. In it, he wrote about all the wonderful new things the explorers saw during their expedition. Many of the men in the Corps of Discovery kept journals, too. Sometimes they even wrote entries in Lewis's journal. During their travels they discovered over a hundred new animals and species which were previously unknown. Among them are grizzly bear, gray wolf, coyote, condor, pronghorn antelope, mountain goat, black-footed ferret, black-billed magpie, black-tailed deer, and prairie dog.

Describe an animal.

Choose one of the animals that Lewis and Clark discovered, and find a picture of it. You may find the animals in books, magazines, at the library, or with your parent's permission, on the Internet. Look carefully at the picture you chose; then, in your journal, describe the animal as if you had never seen it before. Be sure to include as many details as you can. Show your description to someone else, and see if they can guess what animal you described.

Naming Animals

Lewis and Clark gave names to many of the plants and animals they discovered. Two species of birds used the names of the explorers: Lewis' Woodpecker and Clark's Nutcracker. In addition the scientific name for the west slope cutthroat trout—*Oncorhynchus clarki lewisi*—uses a combination of their names. If you were able to name a new species after yourself, what would you call it?

Describe & rename an animal.

Choose an animal that you have seen in real life. It may be a pet or any animal you have seen in nature. Pretend that you are the first person to discover this animal. Draw a picture of it in your journal. Describe the way it looks, sounds, and moves. Include details about where it lives and what it eats. Notice how the names "woodpecker" and "nutcracker" give details about the birds. Think of a creative new name for your animal that tells something about it. See if you can use your own name in part of the animal's new name. For example, a dog might be called "Josh's Bonehider." Be creative! Can you think of a scientific name for your animal, too?

Describing and Naming Plants

On their journey, Lewis and Clark discovered almost 200 new plant species! Red cedar, eastern cottonwood, western wallflower, red-flowering currant, yellow fawn lily, mountain hemlock, whitebark pine, Oregon grape, and silvery buffaloberry are just a few of them. There is even a plant called Lewis' monkey flower!

Describe & rename a plant.

Choose a plant that you have seen in real life. It may be a plant you have seen in your yard or neighborhood. Pretend that you are the first person to discover this plant. Draw a picture of it in your journal. Describe the way it looks. Think of a creative new name for your plant that tells something about it.

Artist Profile: Edward Hicks

Below is a very popular picture in American history called, "The Peaceable Kingdom." It is by Edward Hicks, a preacher who traveled the American countryside preaching and teaching the Bible. He became one of the country's most popular preachers. According to *Three Hundred Years of American Painting* by Alexander Eliot, Hicks did not pass a collection plate or ask for donations when he preached. Instead, he supported his ministry by selling his paintings. Hicks painted about 100 versions of the painting below, which is his most famous work.

"The Peaceable Kingdom" shows what Hicks wanted the world to be like in the **foreground**, and what he wanted to see happen between the Indians and settlers in the **background**. Look at "The Peaceable Kingdom" or find other versions of this painting at the library or, with your parent's permission, on the Internet. Can you recognize the theme of peace in the picture?

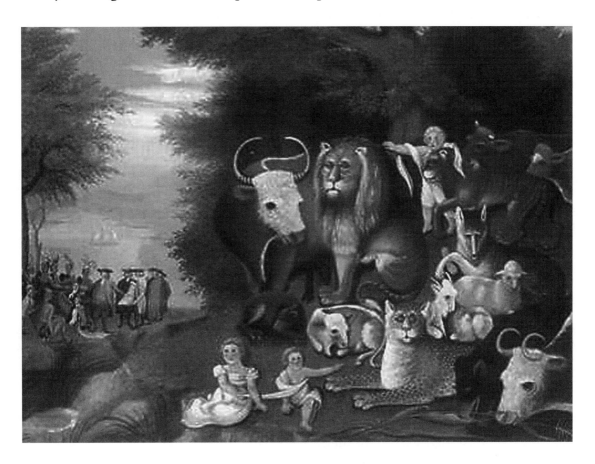

Write about how Lewis and Clark could promote peace.

Think about ways Lewis & Clark could keep peaceful relations with the native tribes they met. Record your ideas in your journal by writing a paragraph of at least two or three sentences.

Draw a cylinder.

Use the drawing on this page to draw the shape of a cylinder in your notebook. Follow the instructions below to learn and practice various shading techniques. Later you will draw and shade a telescope.

Shading

Make your cylinder appear three-dimensional, or rounded, rather than flat by applying **shading**, **shadow**, and **texture**. The goal of shading is to make the object darker on one side than on the other, so that it looks as though light is shining on the object.

To shade an object, first pick the direction the light is coming from. The cylinder on this page shows several ways to apply shading, shadow, and texture to your drawings.

1. *Pointillism.* Use dots or points to create shadow, shade, or texturing. The closer the dots, the more the **value,** or darkness of the color. Likewise the more space between dots, the lighter the value. This technique is also called **stippling**.

2. *Cross-hatching.* Apply cross hatches instead of dots. The more cross hatches used, the darker the shading.

3. *Straight lines.* Draw lines to create shadow. Coming from the side of the drawing, close together, make the edge darker. Notice that the farther from the edge, the fewer lines there are.

4. *Contour lines.* Draw lines with a slight curve that follow the shape of your object. The longer lines are made first, and then shorter lines are added.

5. *Smudging.* Place a pencil lead on the paper at the edge of your drawing, and then spread it toward the center with your finger or with an art tool called a smudge stick.

Some techniques work better on one kind of picture than another, so become familiar with all of them. To shade the cylinder in your journal, try each of the techniques explained here and decide which one you like best.

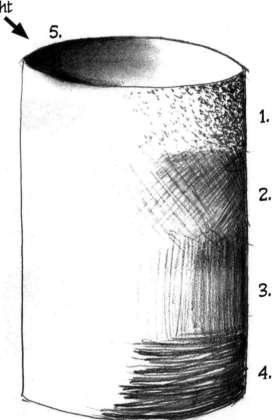

Hint: A large part of being an artist is being observant. Take your drawings and really look at them. Turn them upside down and look carefully. Turn them over on the back and look through the paper by holding it up to a light. What do you see? Are all the vertical lines really vertical? Get a straight edge and lay it along a supposed straight line. Is it straight? Next time you begin drawing, remember what you observed and make corrections before you darken your lines.

Draw and shade a telescope.

Now that you have drawn and shaded a cylinder, you are ready to draw something shaped like a cylinder. Use what you have learned about drawing and shading a cylinder to draw a telescope in your journal. Remember to shade it to show depth in your drawing. Use the telescope on this page to help you.

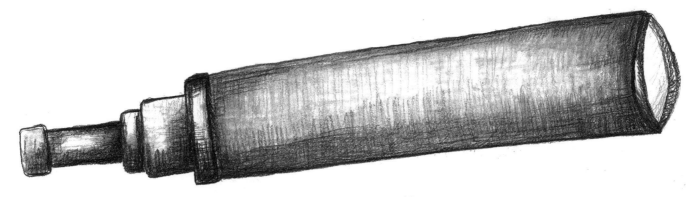

Narrowing Your Focus

Telescopes help to narrow the focus on a small area at a time. Take a paper towel roll and look through it. You will see a small area rather than the big scene. This narrows your focus to see more details on that small area than you would notice while looking at the full scene. A telescope does the same thing, but it also makes the small area look closer. In the same way that a telescope focuses a small area, a window allows you to see just one part of a larger scene. This helps improve observation and drawing skills.

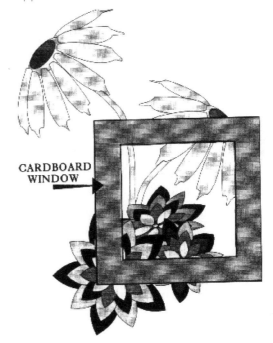

CARDBOARD
WINDOW

Sketch from a narrow focus.

Choose a window in your house that "frames" something outside that you would like to draw. Sketch what you see into your journal. If you would rather, you can make a smaller "window" out of a piece of cardboard or an empty picture frame. Place it on top of a larger picture, and sketch what you see inside the opening.

Using a Grid

You have drawn a simple cylinder and a telescope. Now you will learn about using a grid to help you draw just about anything. Drawing with a grid is a fast, accurate, and simple way to copy a picture. It is so easy that some people think it is almost like cheating. But it isn't cheating—many great artists have used grids to transfer their sketches onto canvases.

To use the grid technique draw a grid over the picture you want to copy. Lightly draw the same size grid on canvas or drawing paper. Then copy the picture using the grid as a guide.

Many times people have trouble drawing things that are more complicated because they try to draw the picture as a whole. This works if a person has very good coordination between the pencil and his eyes. But for the person who is just learning to draw, it is a better to break the object up into smaller pieces and sketch one section at a time. Using the grid technique can help you become a better artist because it lets you see the relationship between each separate part of a whole drawing.

There are two ways to use the grid. One way is to draw the entire outline first, and then go back and complete the inside. (See fig. 1.) The other way is to do one single square at a time, completing each one before going on to the next. (See fig. 2.) Whichever way you use, try to remember to draw what you see, and not what you think you see. When you draw by using a grid it is important to observe the relationships between lines or parts of objects in the picture. Look at the map picture example again in fig. 1. Notice that the tip of Florida is just over the line that runs through the center of the east coast.

When you want to copy or redraw a sketch you have made onto another paper or on canvas, you can transfer it quickly by using a grid. Usually it will look just like the original sketch. You can make your copy bigger or smaller than the original simply by changing the size of the grid line spacing. For example, if you grid the original with one-inch grids, and the copy with four-inch grids, the copy will be four times larger than the original.

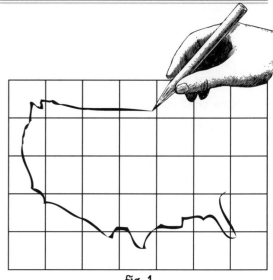

fig. 1

fig. 2

Mapping the Louisiana Purchase

Cartography is the art of mapmaking. A person who makes maps is called a **cartographer**. During the Renaissance, a cartographer named Gerardus Mercator developed the techniques used in modern mapmaking. He was the first to plot a curved surface with straight lines and used this to create a world map that greatly improved navigation. William Clark had the exciting privilege of making the first map of the Louisiana Purchase.

Make your own map of the Louisiana Purchase.

First look at the map of the Louisiana Purchase below. Use the grid technique described on the previous page to help you copy this map. Follow the instructons on the next page if you want to make your map look old.

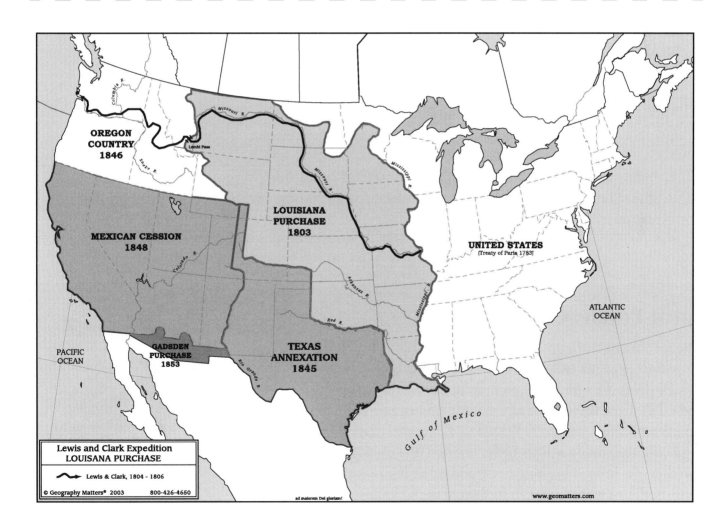

Hint: On this map you can see the area that Lewis and Clark explored. Notice the boundary of the Louisiana Purchase is shaded light gray. Be careful when drawing your map not to mistake the Missouri River for its northern border.

Making a Map Look Old

Try to make your map look as old and worn as possible. You may want to draw the map on a piece of brown paper bag or brown wrapping paper. Or if you draw on white copy paper you can soak the paper in tea or in a mixture of soapsuds and tea. When it is very wet, wad it up, flatten it out, and allow it to dry. The idea is to make your map look as old and worn as possible, so have fun experimenting with ways to do that. When you are finished you might want to write in your journal about how you made your map look old.

Making a 3-D Map

Materials:

Map of the Louisiana Purchase Cardboard, foam board, or scrap mat board
Clay or Salt Dough (see below) Physical map of United States or of Louisiana Purchase
Toothpicks (from a historical atlas, encyclopedia, or the Internet)
Tempura paint (optional)

1. Tape a copy of the Louisiana Purchase map to the cardboard.
2. Place the clay on the map spreading to the edges of the map.
3. Form mountain ranges by using the physical map as a reference.
4. Carve rivers with a toothpick.
5. Paint your 3-D map if you want. Use the same colors in the physical map you use. The colors represent the **topography**, or **texture** of the land.

Salt Dough
2 cups flour
1 cup salt
1 cup water
Mix well. If mixture is crumbly, add a little more water.

Artist Profile: Charles Russell

Charles Russell was a great Amerian painter. He is famous for his paintings of the Indians and the wilderness of the west. Russell painted a number of pictures depicting the Lewis and Clark Expedition. One of the most famous murals in American history is Charles Russell's, "Lewis and Clark Meeting Flathead Indians at Ross Hole." Here is one of his rough sketches of a bronco bucking horse and rider. If you want to see Russell's paintings you can find them at the library or, with your parent's permission, on the Internet. (Try wikimedia.org and enter "Charles Marion Russell" in the search field.)

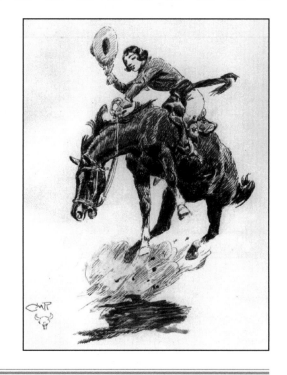

March 25
...the men find numbers of Bee Trees and take great quantities of honey.....The musquetors (mosquitos) are very bad this evening.

– Clark

This is the first entry about mosquitoes, which they called a "troublesome insect."

Draw the other half of this insect.
You might want to use the grid technique.

Drawing a Sphere

Lewis and Clark saw Osage orange trees (also known as hedge apple trees). The Osage Indians highly prized the tree's wood for their bows. The fruit is the shape of a sphere, a bit larger than a softball, is green in color, and has a great deal of **texture**.

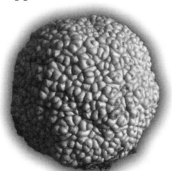

Draw an Osage orange.

First practice by drawing and shading a sphere. Remember to notice where the light is coming from when adding shading. Then look at the Osage orange on this page, at the library, or with your parent's permission, on the Internet. Or gather a real one if they grow near you. Begin with drawing a circle or sphere. Add texture using cross hatching or stippling.

May 18, 20, 25, 28

Lewis signs for $39.74 worth of supplies from Edward Shoemaker and Company, hardware merchant 127 High Street in Philadelphia. He purchased " 2 pair large sheers, 2 dn scissors, 1 rule, 1 set Iron Wts, 1 set Gold scales and some other goods."Articles made by Passmore included"4 Tin Horns, 2 Lamps, 32 Canisters, 1 Square box, 3 dozen pint tumblers.""52 lead canisters for powder are made. That are an ingenious combination of just enough lead and powder so that when the lead is melted down into musket balls there is just enough powder for them"....Benjamin Mifflin of the U.S. surveyor's office, completes an order for tents, blankets, coats, overalls, stockgs, Frocks, sheets, and shirts.

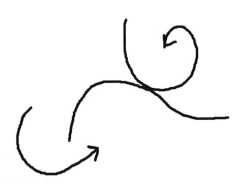

Create a still life.

A **still life** is a grouping of inanimate objects. Make a still life of items mentioned in the expedition journal entry. Lightly block out your **composition** with lines and then use shading, shadow, and texture to complete your still life.

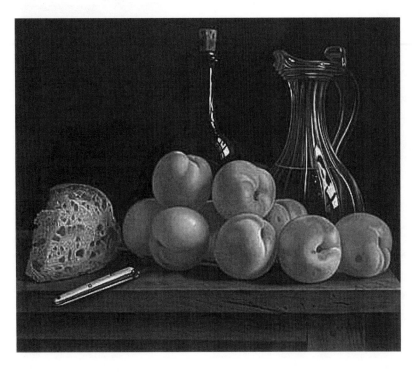

Friday, May 17

...Captain Clark narrowly escaped being bitten by a rattlesnake in the course of his walk, the party killed one this evening at our encampment, which he informed me was similar to that he had seen; this same is smaller than those common to the middle Atlantic States, being about 2 feet 6 inches long; it is of a yellowish brown colour on the back and sides variagated with one row of oval spots of a dark brown colour lying transversely over the back from the neck to the tail, and two other rows of small circular spots of the same coulour which garnish the sides along the edge of the scuta. it's bely contains 176 scuta on belly and 17 on the tail...

- Lewis

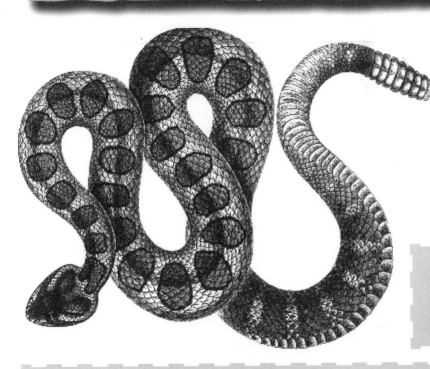

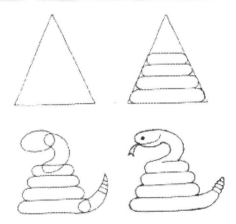

Copy and color the snake.
Use the colors and designs described in Lewis' journal entry above.

Making a Paper Plate Snake

Materials:

paper plate string coloring crayons, markers, or colored pencils

1. Cut the paper plate in coiled shape as shown.
2. Punch two holes in center to attach a string
3. Draw a **pattern**, or repeated design, on the snake.
4. Color your pattern.

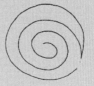

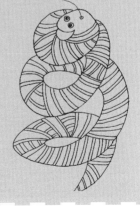

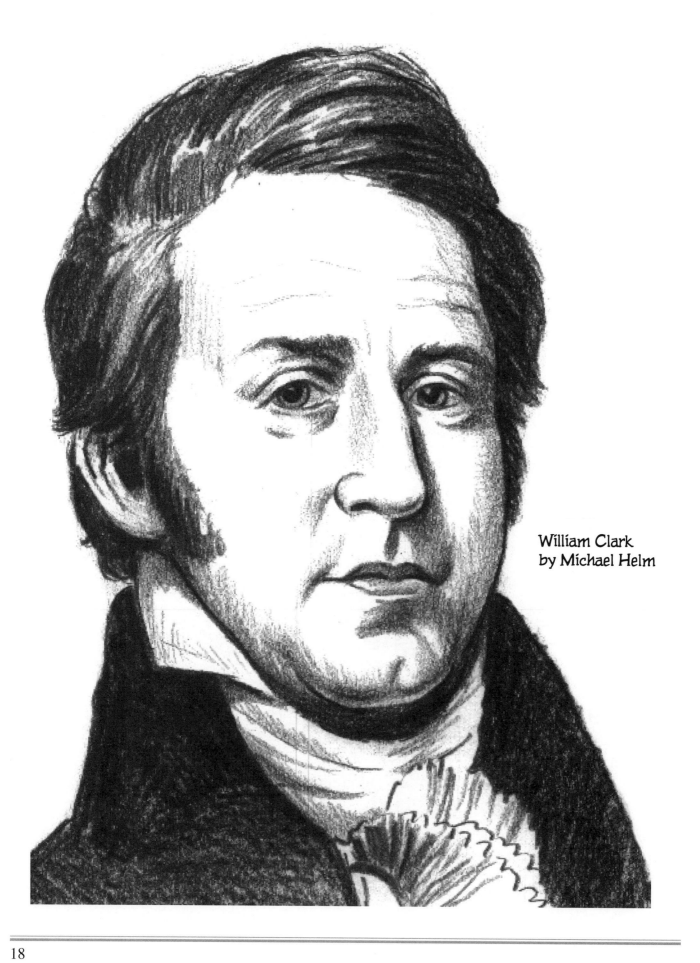

William Clark
by Michael Helm

Drawing a Portrait

Not everyone has the gift of capturing the essence of a person; but everyone can be successful at drawing a face. Below is a face, or **portrait**, done in the classic Greek proportions. In drawing a face, the difference is in the details. Most people have heads that are approximately five times the width of their eye. Try sketching Clark's face using the drawing on the facing page as a reference. Use the structure lines shown below. Always do the structure lines lightly in pencil first and then modify and darken lines as you do the detailing.

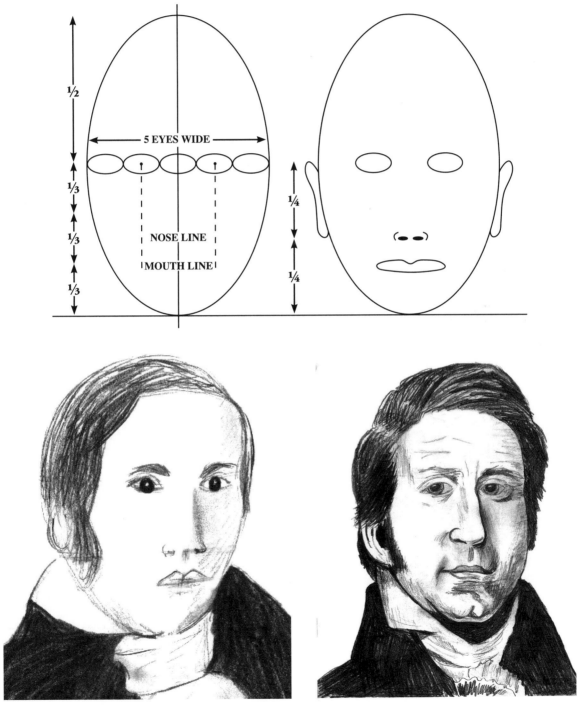

Student Samples

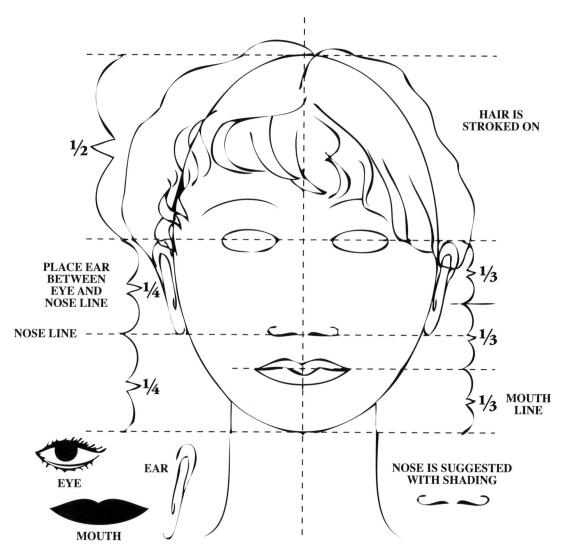

HAIR IS
STROKED ON

1/2

PLACE EAR
BETWEEN
EYE AND
NOSE LINE

1/4

NOSE LINE

1/4

1/3

1/3

1/3 MOUTH
LINE

EYE

EAR

MOUTH

NOSE IS SUGGESTED
WITH SHADING

Draw Lewis and Clark.

Now that you have practiced sketching Clark's face, see if you can draw or copy the pictures of Lewis and of Clark drawn by Michael Helm. You may wish to use the grid technique to help you. Consider the direction of light, and remember to shade accordingly.

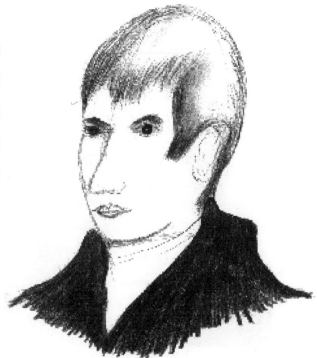

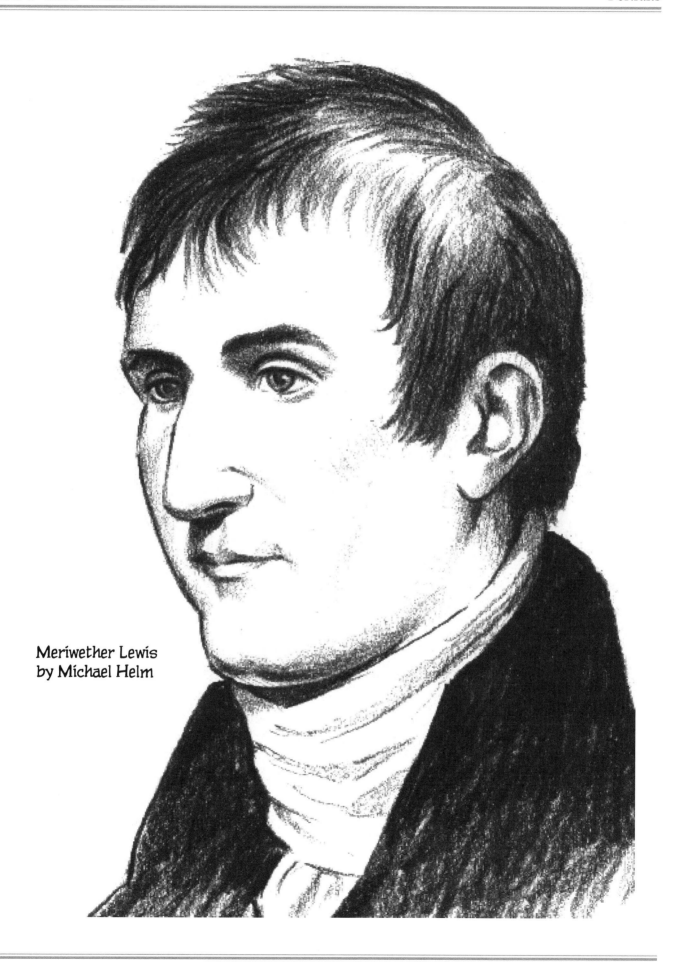

Meriwether Lewis
by Michael Helm

October 4, 1804
...the country from the Missourie to the black mountains is much like the Countrey on the Missourie, less timber and a great proportion of Cedar. The black mountains is very high, and some parts of it has snow in the summer.

— Clark

Drawing Trees

Among the new trees that Lewis and Clark discovered were the western red cedar, eastern cottonwood, the big leaf maple, the Pacific yew, the Ponderosa pine, and the Sitka spruce.

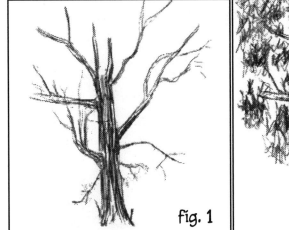
fig. 1

fig. 2

fig. 3

Draw a tree.

Use the instructions below.

1. Start by looking carefully at an actual tree. Draw the trunk and main limbs as in fig. 1.

2. Fill in the broad areas of leaves. You don't have to draw each individual leaf yet. Just define the areas with **shading** and **shadow**s as in fig. 2.

3. Draw individual leaves. Use light and dark leaves to intensify the shadows, give **depth** to the shading and add highlights. Draw individual leaves apart from the shadows or groups of leaves. These individual leaves can be "not connected" to anything, or you may want to draw fine lines to them to indicate the small twigs. (fig.3)

4. Draw the ground line. (fig. 3)

Artist Profile: Albert Bierstadt

Albert Bierstadt was probably one of the greatest **landscape** artists in early American history. He painted the pristine American wilderness. As with many early American artists, Bierstadt trained with the European masters. According to *Three Hundred Years of American Painting* by Alexander Eliot, he remarked that the Rocky Mountains, "resemble very much the Bernese Alps; they are of granite formation, the same as the Swiss mountains.... The grouping of the rocks is charming...the color of the mountains is like those of Italy...," He considered the Rockies his great love and delightfully painted them. Bierstadt's paintings were very large and sold for more than any other American artist had at that time – as much as a startling $35,000. Look at pictures of Bierstadt's paintings at the library or, with your parent's permission, on the Internet. (Try Wikimedia.org and enter "Albert Bierstadt" into the search field.)

> May 26, 1805
> From this point I beheld the Rocky Mountains for the first time......I felt a secret pleasure in finding myself so new the heretofore conceived boundless Missouri....
>
> – Lewis

"Storm in the Rocky Mountains"

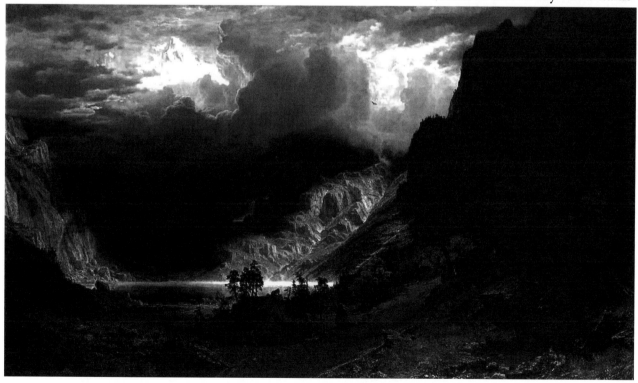

Copy a Master.

Select a painting by Albert Bierstadt or Charles Russell to copy. Use the grid technique. You might find it interesting to turn the painting upside down to copy, as you will tend to focus more on shapes than trying to make a picture.

Landscapes

Many artists develop drawing skills by sketching **landscape**s. You can learn about a variety of flora and fauna by just carefully observing and drawing them. The best way to begin is to go outside with your sketchbook and draw what you see. To make a landscape picture look right it is important to know about proportion and perspective.

Proportion

When drawing a large scene, such as a valley or a view of the mountains, start by drawing a single object like a tree or a house. Once you have sketched this object, use it to "measure" the rest of the scene. This method helps you overcome a common struggle when drawing landscapes–getting objects in the right proportion to one another.

Perspective

In art, perspective is the technique that causes objects in a picture to appear closer or farther away. There are two types of perspective: linear (or mathematical) perspective and atmospheric perspective.

Linear perspective is very apparent in outdoor scenes. This type of perspective is the technique of making things close to you look larger than things that are far away. For instance, the tree in your yard might not really be larger than the house down the street, but when you look at that scene it appears as though it is. Your mailbox might even look larger than a neighbor's car, and this is because of mathematical perspective.

Look at the cloud picture for an example of linear perspective. The clouds in the sky appear smaller and smaller as they run toward the horizon. This is easier to see when the clouds are a layer of puffy white cumulus clouds. These clouds also overlap each cloud that is farther away. This same overlapping takes place with each mountain or tree as you look farther and farther away.

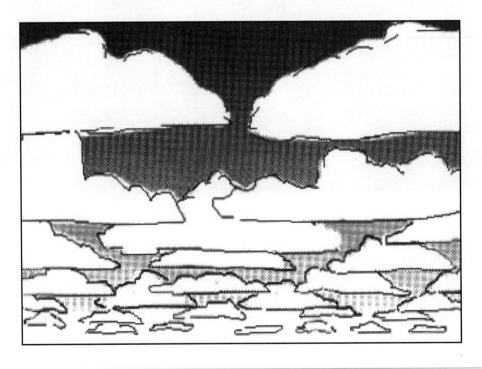

Atmospheric perspective is the apparent reduction of contrast and color when objects are far away. This is easier to understand if you think about what you see when you look at very distant things. For instance, if you live near or have visited the mountains, think about how the ones very close to you appear bright and full of color. As you look at the mountain ridges a little farther away, they seem to have less color and definition, until the very farthest ones are almost light blue. The same thing happens in the sky. On the far away horizon line the sky is a light blue, but as you look higher and higher in the sky the color becomes a deeper blue. If there are clouds, the ones overhead seem to be a much brighter white than the ones on the horizon. This color difference is caused by atmospheric conditions, such as water vapor and dust.

Notice how the sky is darker at the top of the picture and lightens as it gets closer to the horizon line. Then, consider how large the tree in the **foreground** is compared to the mountains. Of course, you know the tree is not really larger than the mountains—it only seems to be because it is closer. These are examples of atmospheric and linear perspective.

Draw a landscape.

Take your journal outside and draw what you see. Try to apply what you have learned about proportion and perspective in your drawing. Include shading, texture, and other art techniques you have learned. You may want to review the lesson on drawing trees before you begin.

One-Point Perspective

Learning to draw with perspective gives **depth** to your pictures. The railroad in this picture is an example of **one-point perspective**. Notice that it looks as though it is getting smaller and smaller as it goes into the distance. The farthest distance you see in this drawing is called the **vanishing point**. Follow these simple rules for drawing a picture using one-point perspective.

• All horizontal lines are horizontal.

• All vertical lines are vertical.

• All other lines meet at the vanishing point.

October 10

...at 1 oclock the Chiefs all assembled under an orning near the Boat, and under the American Flag. We Delivered a Similar Speech to those delivered the Ottoes and Sioux....after the Council was over we Shot the Air gun, which astonished them.

- Clark

Notice how the figures in the **foreground** are larger and the figures in the **background** are smaller. This is an example of linear perspective.

Draw a one-point perspective picture of Lewis & Clark on a trail.
Use the one-point perspective rules.

December 31

...The Fort which we built here and which we named Fort Mandan is situated on the North East side of the Mesouri River. It was built in a trainglular form with its base fronting the same, has a platform on the No. Side 12 feet high with Pickets on it, six feet, and a room of 12 square feet, the under part servings as a Storehouse for provisions and CA. The three sides were 60 feet in length each, and picketted on the front side only, with pickets of 18 feet long and the houses which we resided in lay on the South West side and the Smith and Armourer workshop was at the south point of the Fort.

- W

This journal entry was probably written by a member of the Corps of Discovery.

Two-Point Perspective

In a **two-point perspective** picture, the rules are:

• All vertical lines are vertical.
• All other straight lines go to the vanishing points.

Observe the two **vanishing points** in the square in fig.1.

Fort Mandan was built by the expedition members in 1804. It is located in Washburn, North Dakota. Clark calculated that the party had traveled 1609 miles from Camp River Dubois at the mouth of the Missouri to this winter encampment.

You can tell the approximate size of the fort because of the person standing in front of it. This is drawing something to **scale**.

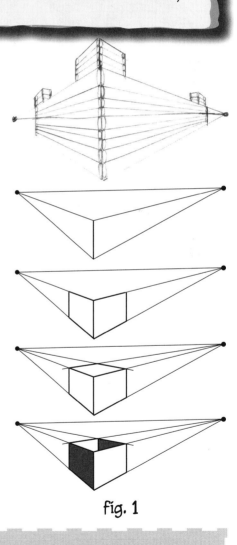

fig. 1

Draw a two-point perspective picture of Lewis & Clark on a trail.
Use the two-point perspective rules.

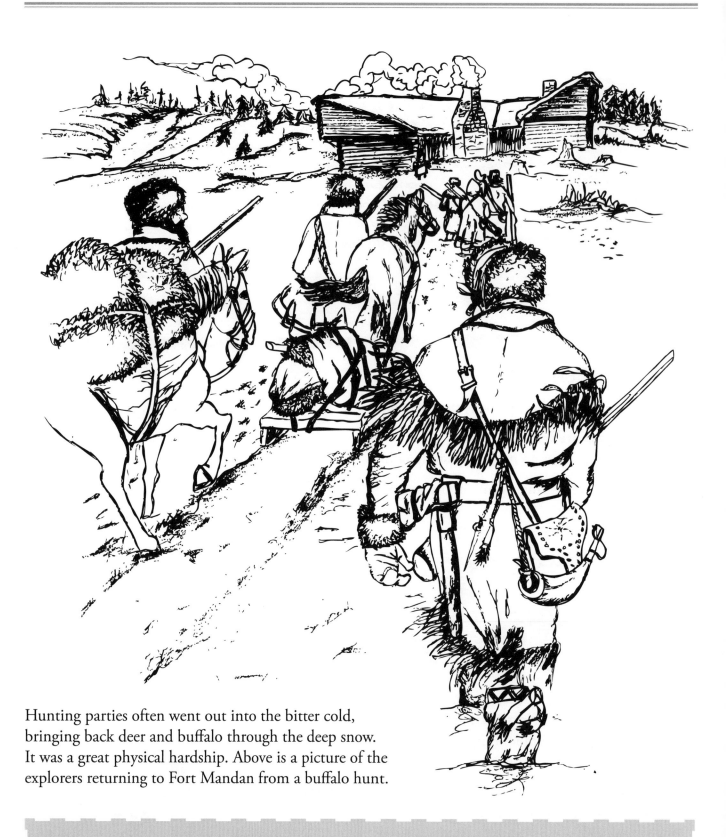

Hunting parties often went out into the bitter cold,
bringing back deer and buffalo through the deep snow.
It was a great physical hardship. Above is a picture of the
explorers returning to Fort Mandan from a buffalo hunt.

Copy and color this picture.

Notice how the person in the foreground of the picture is larger than the fort in the back-
ground. This is another example of linear perspective, which helps artists add depth to pictures.

June 13, 1805
From the reflection of the sun on the sprey....which arises from these
falls there is a beautiful rainbow produced which adds not a little to the
beauty of this....grand scenery.

- Lewis

Make a color wheel.

Draw a circle, or trace the circle on this
page. Draw three lines across the circle,
equal distances apart and intersecting in the
middle. Color in the spaces with the correct
colors as shown. Be sure to put the colors in
the right order.

Draw an animal as a color wheel.

Choose an animal that Lewis and Clark
might have seen. Draw the animal, and
color it the same colors of the color wheel.
Be sure to put the colors in the right order.
Use the tree frog on this page as an example.

Primary colors are red, blue, and yellow. Colors
across the wheel compliment each other. You can
make any color in the world using the primary
colors.

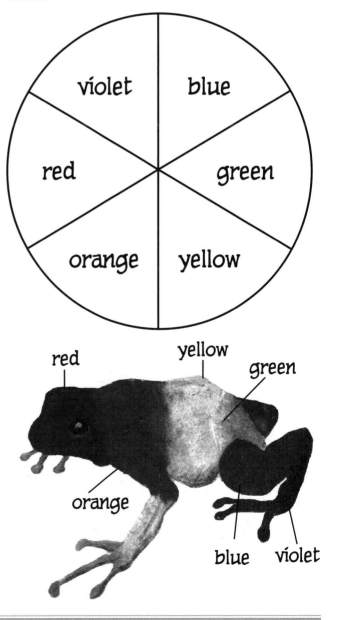

July 20, 1805
I went out above the mouth of
this creek and walked the greater
part of the day thro:Plains in-
terspersed with Small Groves of
Timber...I killed a Verry large yellow
wolf, The Soil of Those Praries ap-
pears rich but much Parched with
frequent fires.

- Clark

Captain Clark wrote, " I observed two beautiful canoes, tapered to each end, on the bow curious figures were cut in the wood."

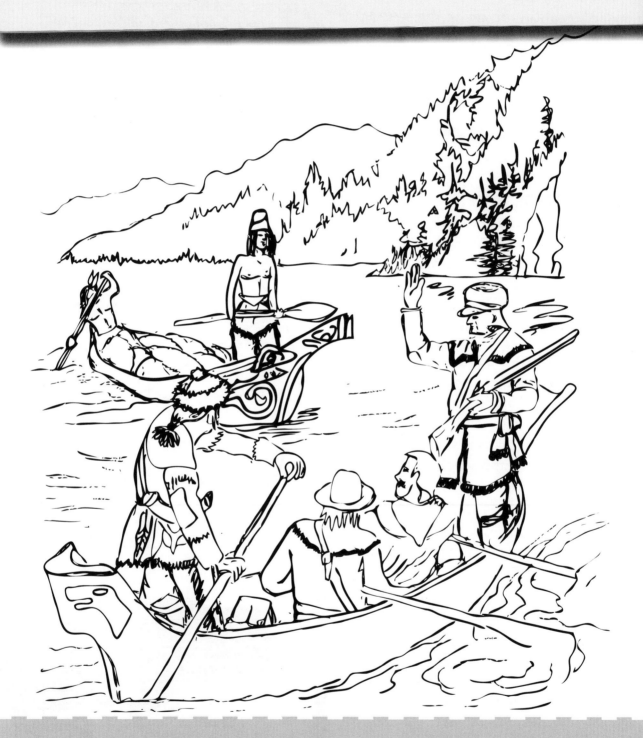

Color this picture in cool colors.

Cool colors are green, blue, and purple. What do you think the individuals in this picture talked about? In your journal write about a conversation they could have had.

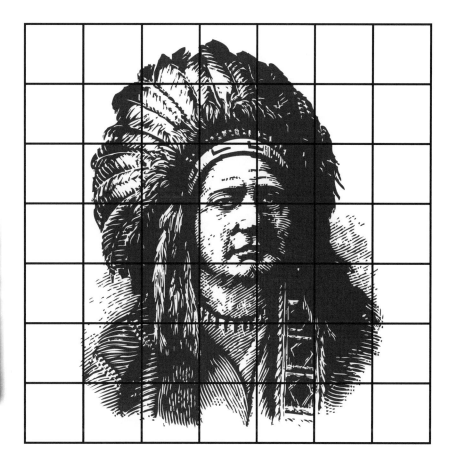

August 13, 1806

The Shoshonis embraced me very affectionately and we were all carresed and besmeared with their grease and paint till I was heartily tired of the national hug. I now had the pipe lit and gave them a smoke...

— Lewis

Draw an Indian.

Draw any Indian of your choice, or use the grid technique to copy the Indian on this page.

Please note: In Lewis and Clark's day Native Americans were called Indians. We've used the term *Indian* in this book in keeping with the historical usage. No offense is intended to Native Americans.

September 25

...Several Indians Come to See us this evening, amongst others the Sun of the late great Chief of the Mandans, this man has his two little fingers off- :on inqureing the Cause, was told it was Customary for this nation to Show their grief by Some testimony of pain, and that is was not uncommon for them to take off two smaller fingers...

— Clark

Indian Art

This picture is about a battle scene between the Sioux and the Crow. There are teepees and blood in the lower right. It is dated in the mid-19th Century and is painted on a buffalo hide.

Repeating designs in a picture create a visual **rhythm**. Look for visual rhythm in this picture; can you see it?

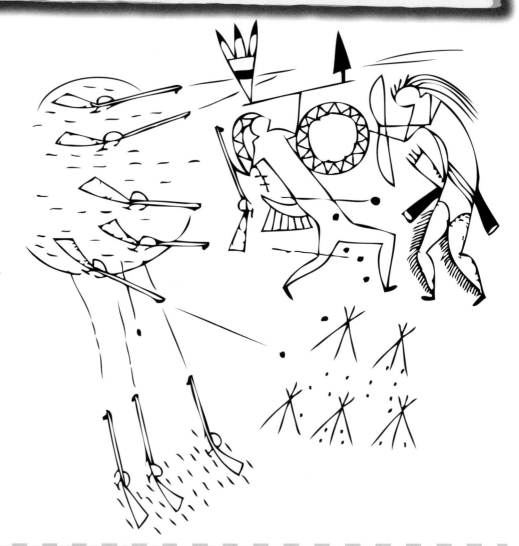

Make a symbolic drawing on paper that looks like buffalo hide.

Be an inventor and try to get a piece of paper to look like a buffalo hide. You can soak it in tea, use brown watercolor paint, or think of another way to give your paper the look and feel of hide. Describe in your journal how you made the paper look and feel like buffalo hide.

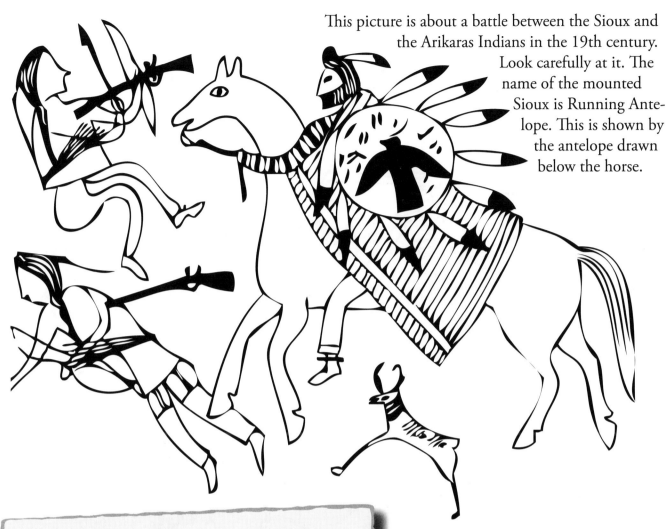

This picture is about a battle between the Sioux and the Arikaras Indians in the 19th century. Look carefully at it. The name of the mounted Sioux is Running Antelope. This is shown by the antelope drawn below the horse.

September 23

...we observed...Smoke to the SW...an Indian Signal of their having discovered us...Came to and Camped...three Soues boys swam..to us....informed us that a band of Sieux called the Tetons were Camped near.....we wished to speak to-morrow at the mouth of the next river.

– Clark

Symbolism in Indian Art

Native American drawings are very symbolic and were often painted on buffalo hide. They usually tell stories about things that actually happened, and there is seldom any shading, shadow, or texture on them. Throughout history, artists have recorded important events in a variety of ways. Today cameras are used to take pictures of battle scenes and other important happenings.

Color the above picture.

Copy the picture by tracing, photocopying, or with the grid technique. Color it in anyway you choose with any medium of your choice. Place or tape it into your journal.

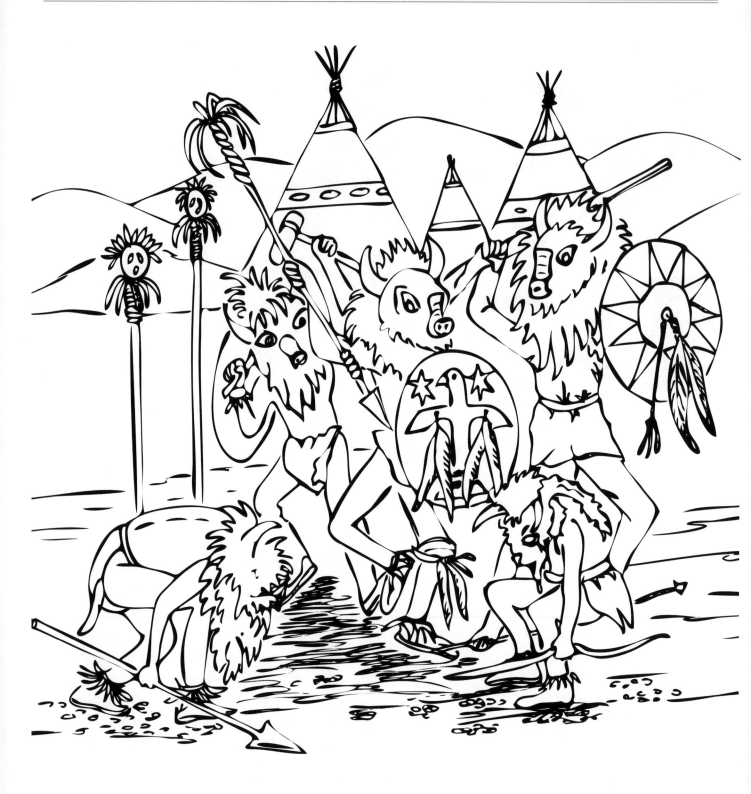

Buffalo Dance of the Mandan Indians

The Mandan Indians performed a dance to attract buffalo. This was probably an entertainment that the men of the expedition enjoyed!

Color the picture in hot colors.
Hot colors are red, yellow, and orange.

Monday September 17, 1804

...this scenery already rich pleasing and beautiful was still farther heightened by immense herds of buffalo, deer elk, and atelopes which we saw in every direction feeding on the hills and plains. I do not think I exaggerate when I estimate the number of buffalo which could be comprehended at one view to be 3000.

– Lewis

Draw buffalo.
Draw as many as you can fit on one page. Use the basic shapes shown on this page to help you.

Write about what happened to the buffalo.

Do you know what happened to the vast herds of buffalo that used to live in our country? Look in the library or, with your parent's permission, on the Internet to see if you can find out. Write about what you learned. Include two or three sentences.

October 21, 1804
We had a desagreeable night of sleet and hail. It snowed during the forenoon, but we proceeded early on the voyage.

-Patrick Gass

a verry Cold night...Some rain in the night which frose as it fell at Day light it began to snow.

- Clark

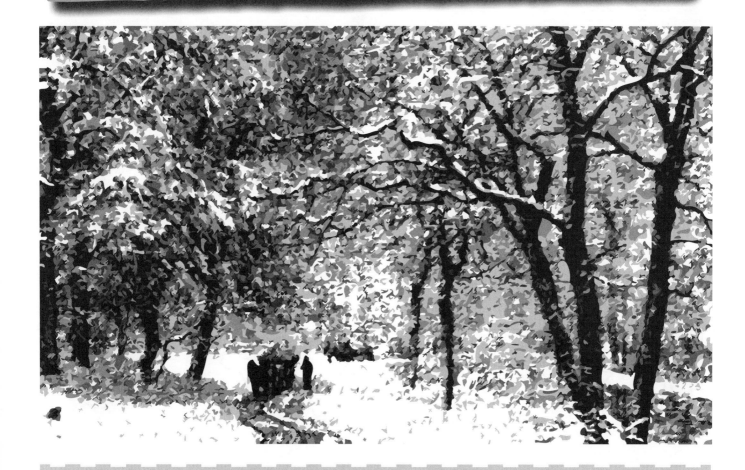

Draw a winter scene using a monochromatic color scheme.

A **monochromatic** color scheme is one that uses various shades of one color and sometimes white. The picture above is monochromatic because it is colored entirely by white and various shades of black. Use blue and white in your drawing. Blue is a cool color so when you use it in a sketch the scene will look very cold. Under your drawing write two or three sentences about the cold winter scene.

Seaman

Seaman was the name of the Newfoundland dog owned by Lewis. He purchased the animal while waiting for his keelboat to be finished in August of 1803.

Draw pictures of Seaman.

Use the structure lies below. First sketch with your black pencil on white paper, then draw another one on black paper using white chalk. The black is **negative space**, and the white is **positive space**.

1. Use ovals to define space.

2. Use contour lines to define shape.

3. Add **shading** to give form. Try using **stippling** to shade.

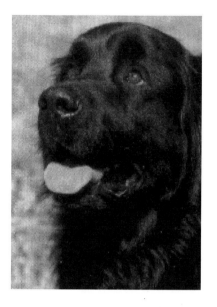

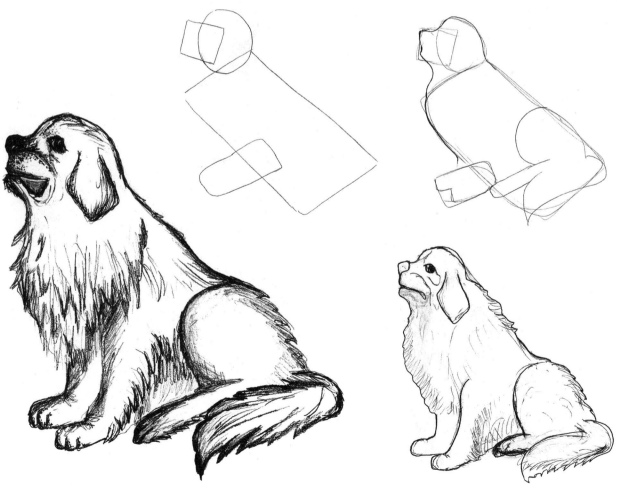

December 9, 10

Capt Lewis took 18 men and 4 horses and went out. Send in the meet killed yesterday and kill more, the Sun shown today clear. Capt. Lewis and several of the hunters returned to the fort...with large loads of meat. The weather gits colder verry fast so that the sentinel had to be relieved every hour....

– Clark

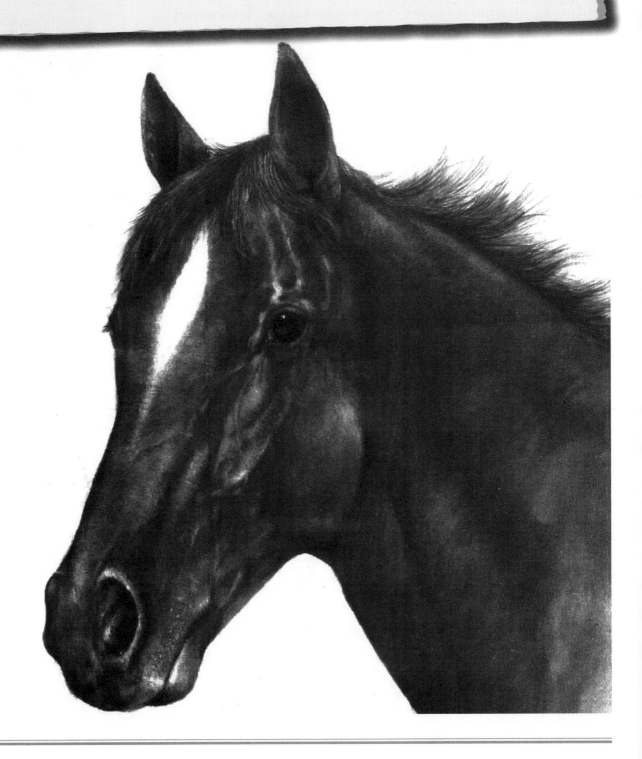

These lines represent the center lines of the horse.

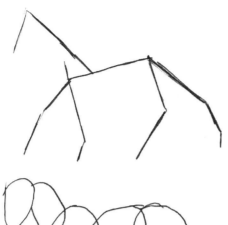

These circles and ovals represent the space used by this drawing of a horse.

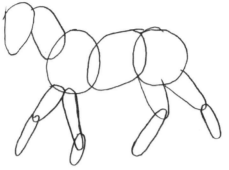

Draw a horse.

Use the step-by-step drawing instructions provided to create a framework for sketching your horse. The step-by-step sample of the horse's head should help you draw details of the head in proportion. It is always helpful to have a reference picture or drawing, so be sure to look at the horse picture on the facing page as a sample.

Using the center lines as a guide, and the circles and ovals as space, you can get the general layout of the horse.

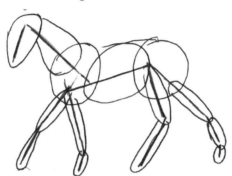

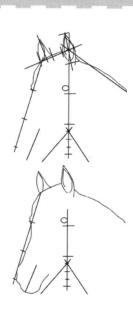

After you have the general layout, begin drawing the details.

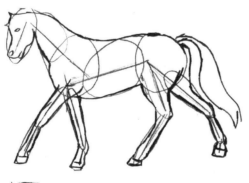

This is the completed outline of the horse.

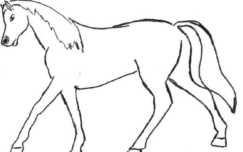

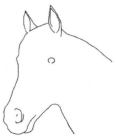

Monday, May 6, 1805

...saw a brown (grizzly) bear swim the river above us, he disappeared before we can get in reach of him; I find that the curiossity of our party is pretty well satisfied with rispect to this animal. The formidible appearance of the male bear killed on the 5th added to the difficulty with which they die when shot through the vital parts, has staggered the resolution of several of them, others however seem keen for action with the bear. I expect these gentlemen will give us some amusement shorly...

October 7, 1804

At the mouth of this river we saw the tracks of white (grizzley) bear which was very large, I walked up this river a mile. ...One of the men killed a Shee Brarrow, another killed a black tail deer, the largest doe I ever saw.

— Lewis

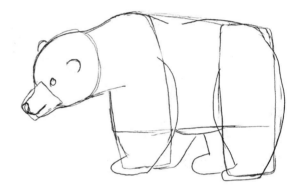

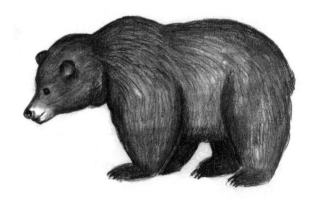

Draw a Bear.

Use the basic shapes above for drawing a bear. Erase the guide lines before you add shading, shadow, and texture to make it look real. Younger children can use more basic shapes on the left to draw a bear.

October 7, 1804

At the mouth of this river we saw the tracks of white (grizzley) bear which was very large, I walked up this river a mile. ...One of the men killed a Shee Brarrow, another killed a black tail deer, the largest doe I ever saw.

- Lewis

On May 14, 1805, one of the party was chased and nearly killed by a bear. Captain Lewis wrote: " I had rather fight two Indians than one bear."

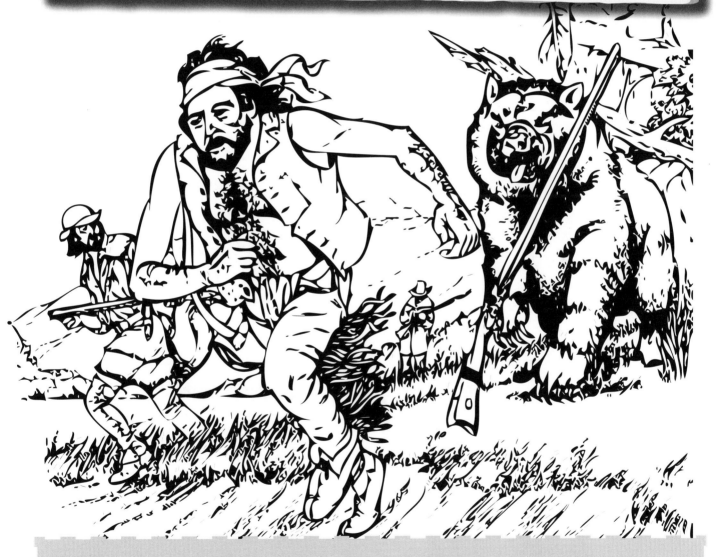

Write a descriptive paragraph describing the scene above.

A descriptive paragraph is made of several sentences that describe something. Give details so someone who has not seen the picture can draw a picture in their mind. Try to include at least three sentences in your paragraph. Color the picture.

June 30

..."Saw a verry large wolf on the Sand bar this morning walking near a gange of Turkeys....Deer to be seen in every direction and their tracks ar as plenty as Hogs about a farm....Killed 9 deer today...."

" I killed a prairie wolf today about the size of a Gray fox with a bushey tail the head and ears like a Fox wolf, and barks like a small dog–The annimale which we have taken for the Fox is this wolf, we have seen no Foxes."

– Clark

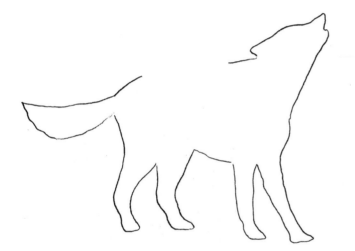

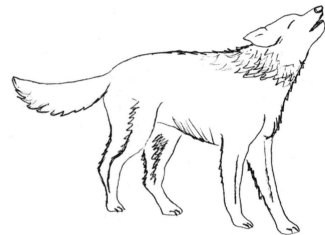

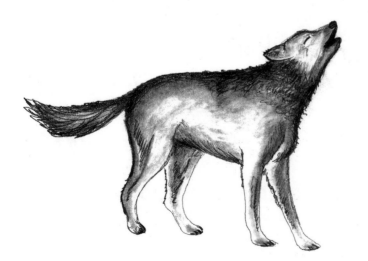

Draw a wolf.

Use contour outline drawing, which is simply drawing the outline of an object with one continuous line. To do this your focus should be on the outside edges of the object you are drawing. Start the drawing by making a continuous outline drawing of the wolf. Complete the outline where you started. You may wish to add outlines of shading and highlights for texture.

Draw the deer using basic shapes.

Use a triangle for the head and various sizes of rectangles for the body and legs.

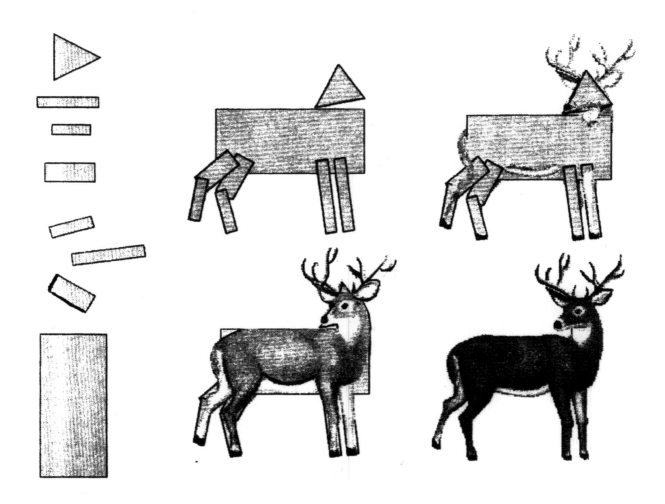

October 5, 1805

" I shot a buck, saw a large gang of goat on the hill opposite, one buck was killed, also a prairie wolf this evening."

— Lewis

January 19,

" Some snow fell last night, a Cloudy morning, the river continues to fall, & Some Ice running...Gibson Killed 3 Deer and Colter 3 Turkey Shields 4 Turkey, Warner and Thompson 14 rabbits."

— Clark

Using a Grid to Draw a Deer

In the next few pages you will learn two techniques to draw a deer using a grid. This example shows the steps involved to draw a deer by outlining its shape first. First place a grid over the picture to be copied. Then make a complete line drawing on a blank grid of the same size. Next shade the picture. It is helpful to number the grid blocks on both grids to keep from losing your place. This also helps you draw the copy positioned on the page where you want it.

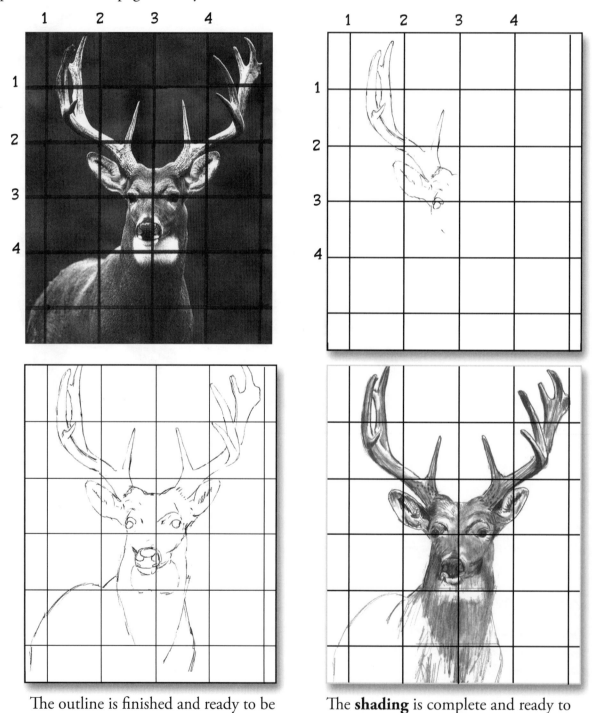

The outline is finished and ready to be shaded.

The **shading** is complete and ready to smudge.

1

Using a window in a grid

One technique using a grid makes use of drawing one grid block at a time. Read the instructions below to learn how.

1. Cut a hole the size of the grid square into a piece of paper.

2. Make a grid over the picture you want to copy.

3. Grid a blank sheet of paper with the same size grid.

4. Cover the entire picture allowing only one square to show through the hole.

5. Copy that one grid square in its entirety. Be sure to use the same location on the blank grid as the grid you see through the window.

6. Continue one grid square at a time until the picture is complete.

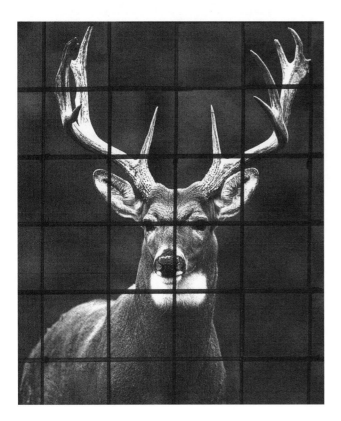

2

3

4

5

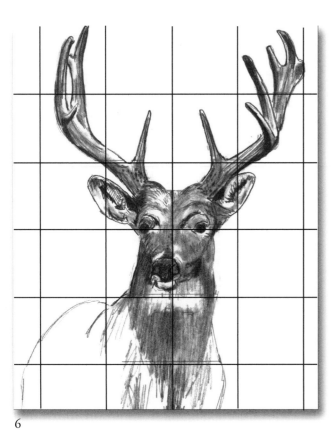

6

This completed sketch includes additional shading and texture techniques.

Make your own grid drawings.

1. Find several pictures that you would like to draw.
2. Grid them with one-inch squares.
3. Grid your sketchbook with the same size grid.
4. Draw the picture in your sketchbook using the grid you prepared.
5. Grid your sketchbook with two-inch grids and copy the picture again.
6. Grid your sketchbook a third time. This time use three-inch grids, and copy the picture once again.

Repeat this process with other pictures. When you are finished with your drawings, erase the grid lines. You should notice that smaller grids provide greater detail, but when you use wider grids you can draw faster.

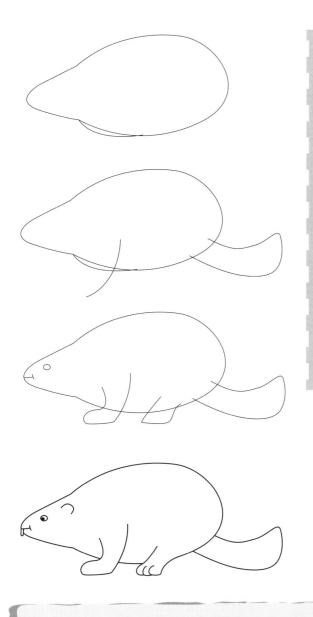

Draw a beaver using basic shapes.

Practice drawing a beaver by using the illustrations on this page. When you are satisfied with your sketch, look carefully at the pictures like the one below. Then complete your drawing by including things that show what a beaver's natural **habitat** is like. You can find other pictures of beavers at the library or, with your parent's permission, on the Internet.

Write about beaver sightings.

Write two or more sentences in your journal on the page with your beaver drawing. If you wish, you may choose to copy a quote from Lewis's journal as a caption for your drawing.

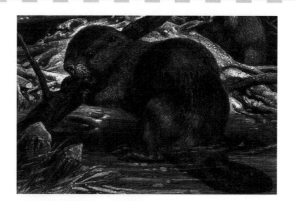

Wednesday April 10

...at 1:00 P.M We overtook three french hunters who had set off a few days before us with a view of trapping beaver. They had since taken twelve since they left Fort Mandan. these people avail themselves of the protection which our numbers will enable us to give them...and continue their hunt up that river. this is the first essay of a beaver hunter of any disription on this river... the beaver these people have already taken is by far the best we have ever seen.

November 3, 1804

We commenced building our cabins...two beavers caught this morning, and one trap was lost.

— Lewis

September 7, 1804
...discovered a Village of Small animals that burrow in the grown....those animals are about the size of a small squrel (shorter) &

thicker...Shields killed a prairie dog which was cooked for the captain's dinner.

February 13, 1805
I returned last night from a hunting party much fatigued, having walked 30 miles on the ice and through Points of wood land in which the snow was nearly knee deep.

- Clark

Drawing a squirrel

This squirrel is drawn by using an **implied grid**. In this case, an oval is drawn over the squirrel's head and then used to "measure" the rest of the picture and determine the animal's proportions.

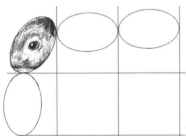 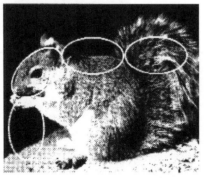

Draw a squirrel.

Use the implied grid method. When you are finished make the background blue. We know Lewis and Clark endured weather that was very cold and produced great hardships. Use white tempera paint and cover the finished squirrel picture with dots for snow. You might even put the squirrel in a blizzard similar to what the explorers might have seen.

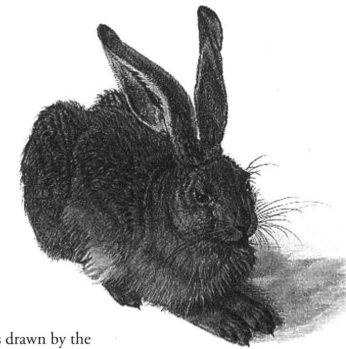

January 14
" A snow fall last night of
about an Inch (and one)
half....the party Caught 14 ra-
bits today and 7 yesterday. A
cold afternoon. The Missis-
sippi is Claosed with Ice.

 - Clark

Drawing a Rabbit

The rabbit on this page is a picture of one that was drawn by the
famous master artist of the high German Renaissance, Albrecht Durer. Notice
how shading, shadow, and texture make the rabbit look real. This is called **implied texture.**

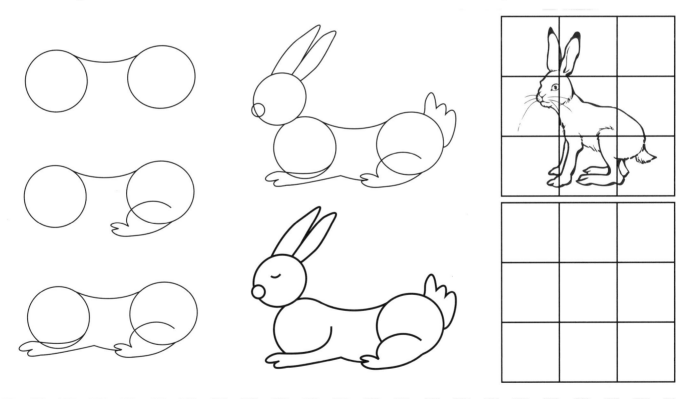

Draw rabbits using basic shapes and using a grid.
Use the basic shapes shown on this page to practice drawing rabbits in your journal. Then try
using a grid. Which way do you prefer?

December 5, 12 1804
...a Cold raw morinig...Some Snow, tow of the NW Cmonaey Came to see us.... I line my gloves and have a cap made of the Skin of the Lynx...the fur near 3 inches long...weather is so cold that we do nothink it prudent to turn out to hunt.

Drawing Methods

Several different methods of drawing have been discussed in this book, and when practiced, these methods can be used effectively to draw anything. Among other things, you have learned techniques that allow you to define space with basic shapes; define shape with contour lines, shading, and shadows; and apply texture as a finishing touch. You have worked with grids and implied grids, which use a small part to "measure" the rest of the picture.

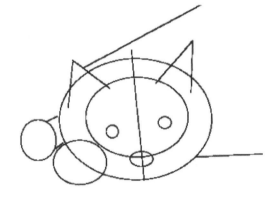

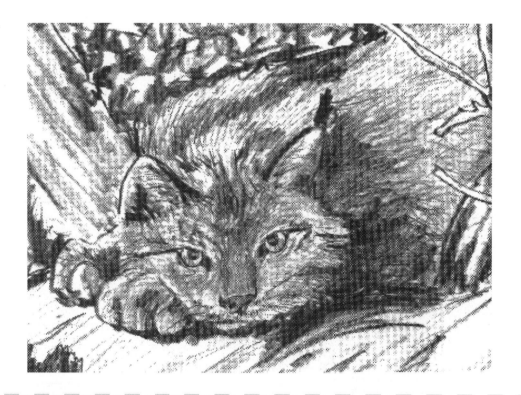

Draw the lynx.
Draw the lynx and then think of five adjectives about the lynx. **Adjectives** are words that describe things. Write the adjectives around the animal.

Artist Profile: John James Audubon

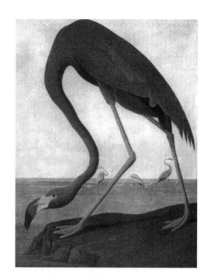

According to *Three Hundred Years of American Painting*, John James Audubon knew the birds of America better than any living man. "...I take one neatly killed, put him up with wires and when satisfied with the truth of the position, I take my palette and work as rapidly as possible.... I finish a bird at one sitting—often it is true of fourteen hours—so I think they are correct, both in detail and composition."

Look at the copy of Audubon's pink flamingo. He put his birds in their natural **habitats** and always created a striking **composition**. When you make a picture of something in nature, be aware of its surroundings and of the composition of your picture.

Draw lots of turkeys.

Use the basic shapes on this page to practice drawing turkeys. Make sure their eyes are very dark. The eye of a bird is always the darkest place of the bird.

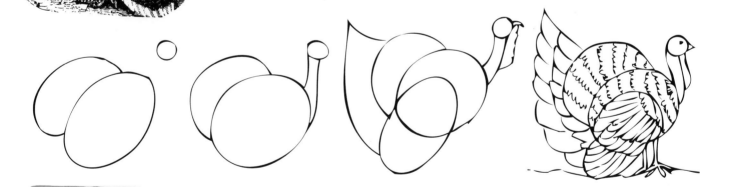

August 25

...at 1:00 P.M We overtook three french hunters who had set off a few days This morning...Visit the mountain of evel Spirits...we observed. Great numbers of birds hovering about the top of this Mound when I got on top those birds flew off. I discovered that they were catching a...flying ant which were in great numbers...those insects lit on our hats and necks, Several of them bit me verry Sharp on the neck...

– Clark

Eagles

Lewis and Clark observed the eagle on their journey.

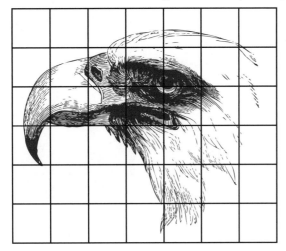

The bald eagle is a symbol of the United States. A **symbol** is something that stands for or represents something else.

Design a symbol.

Create a symbol to represent the historic journey of Lewis & Clark. Look at the examples of using the eagle in a grouping (fig. 1). Be creative and use things that remind you of the Lewis and Clark Expedition. You might include things like a telescope, a compass, a map, plants and animals they discovered, or anything else you would like. Good designs often use an odd number of objects, and always look "balanced."

Draw the eagle.

Use the grid technique to draw an eagle. Think about reasons why the eagle was chosen to symbolize the United States. Write your ideas in two or three sentences under your drawing.

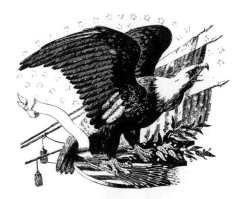

fig. 1

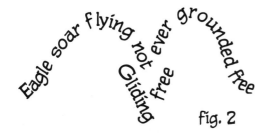

fig. 2

Concrete poetry is a type of poetry where words are variously arranged in a similar shape as the subject of the poem. (See fig. 2) This creates visual as well as poetic images.

Write a concrete poem.

Write about an animal that Lewis and Clark saw. It may be helpful to look at some other examples of concrete poetry at the library or, with your parent's permission, on the Internet.

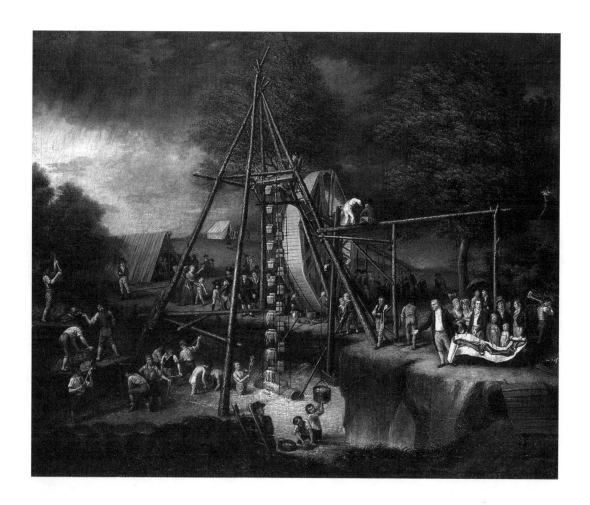

Artist Profile: Charles Peale

Look carefully at the picture on this page. You might wonder what it has to do with Lewis and Clark. It was painted in 1806 by Charles Peale, one of the most famous American artists of this period. Many early American artists were also scientists, and he is a perfect example of this fact. Peale found an amazing way to present natural history. According to Eliot's *Three Hundred Years of American Painting,* he came up with the idea of stuffing animals for his museum and then placing them in a setting that reflected their natural habitats. He displayed more than 100,000 items in his natural history museum, which is considered the first in America.

Charles Peale was a very interesting person. The painting above, "Exhuming the First Mastodon," tells about the time he paid a farmer $300, a rifle, and a couple of dresses for permission to dig up bones on the farmer's property. He invented a smokeless stove, set elk's teeth in lead to make new dentures for George Washington, and repaired the pipe that President Jefferson smoked when conferring with Indian chiefs.

As a painter Peale was a master. He painted the most widely known portraits of George Washington, Thomas Jefferson, Meriwether Lewis, and William Clark. His portrait of "Washington at Princeton" painted in 1779, sold for more than $21 million in 2005—the highest ever paid for an American portrait.

Copying a Master

Copying a painting by a master artist can teach you a lot about **composition** and design. This sketch is a copy of "Exuming the Mastedon."

Copy "Exhuming the First Mastedon".

Look at the picture of this painting, rather than the sketch on this page, to do your drawing.
You can find it in full color at the library or, with your parent's permission, on the Internet. (Try Wikimedia.org and enter Charles Peale in the search field.)

Creating an Original Composition

The picture below has the world combined in an interesting visual way with the buffalo. The picture has lots of movement. You have practiced drawing several animals seen by Lewis and Clark. Put together at least four animals in an interesting visual way. It does not have to be a realistic picture.

August 23

G. Drewyer and Jo Fields went hunting...Captain Lewis walked on Shore a Short time and killed a fine Buck. We halted to breakfast....at the same time Jo Fields came to the boat informed us that he had killed a Bull Buffalo. Captain Lewis and myself and 10 more....butchered and brought it to the boat...this is the first buffalo killed by the Corps.

- Clark

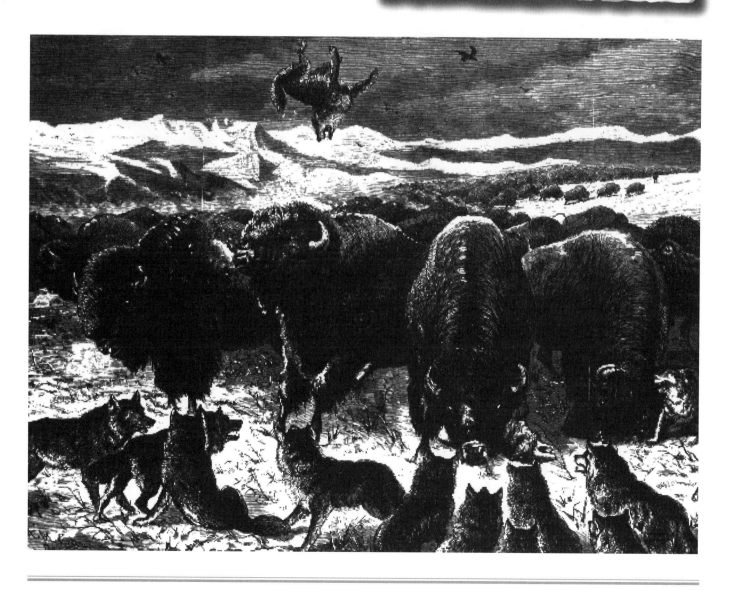

Plesiosaur

Lewis and Clark found the remains of a plesiosaur. This was an aquatic dinosaur of the Mesozoic era. It wasn't until 1842 that the word dinosaur was coined by Sir Richard Owen, who was born July 20, 1804, and only six weeks old at the time of this discovery!

What a plesiosaur might have looked like: http://njfossils.net/plesiosaur.html

September 10
"we found a back bone with most of the entire laying connected for 45 feet those bones are petrified, Some teeth and ribs were also connected."

– Clark

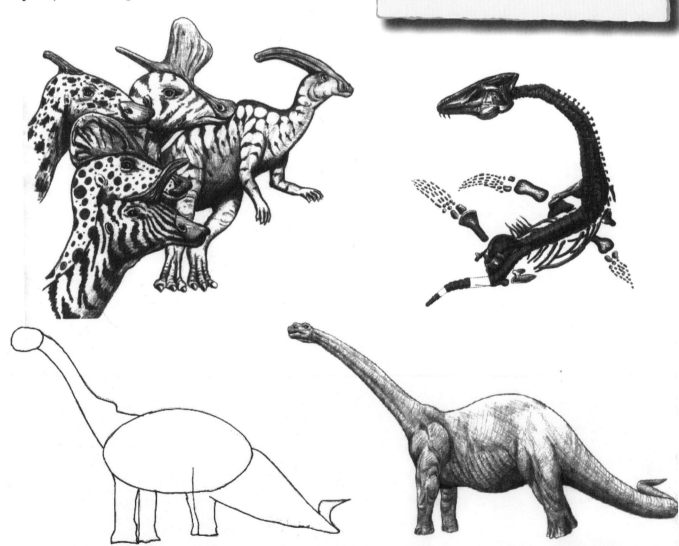

Draw a plesiosaur.
Draw a dinosaur around the bones in the picture above. Draw several dinosaurs and put a different pattern on each of them. See the examples on the next two pages to help you draw another dinosaur.

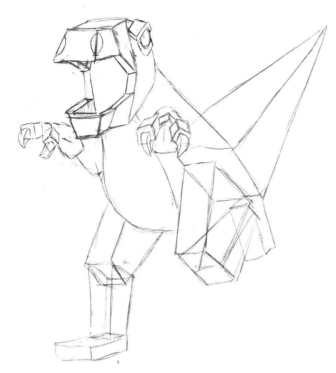

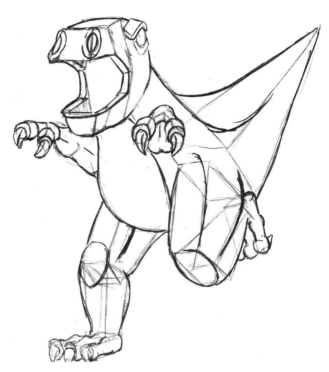

This dinosaur was made using blocks to occupy a space and define a shape.

Next, it is rounded off and filled in with details such as toes.

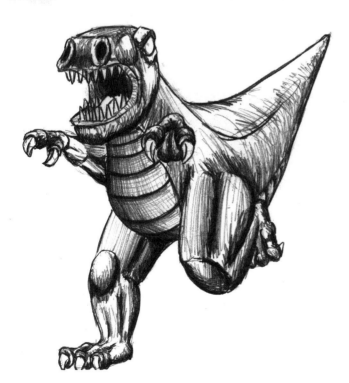

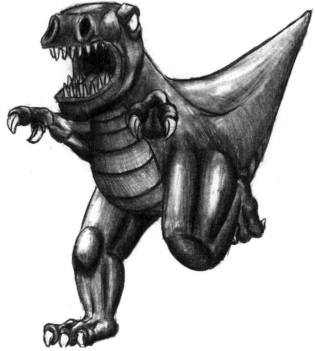

The figure is shaded with a light source from above and to the right.

The shading is blended with a smudge stick for a smoother **gradient.**

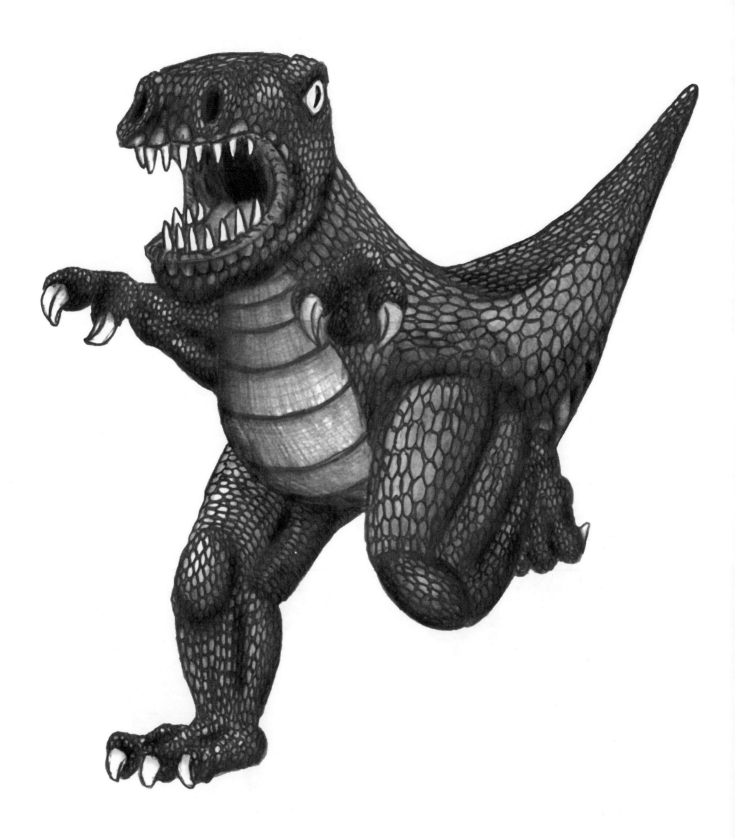

Lewis and Clark's Route

Test yourself. Draw the course taken by the Lewis and Clark Expedition on the map below. Shade and label the Louisiana Purchase. Use the map on page 18 to see how well you remembered.

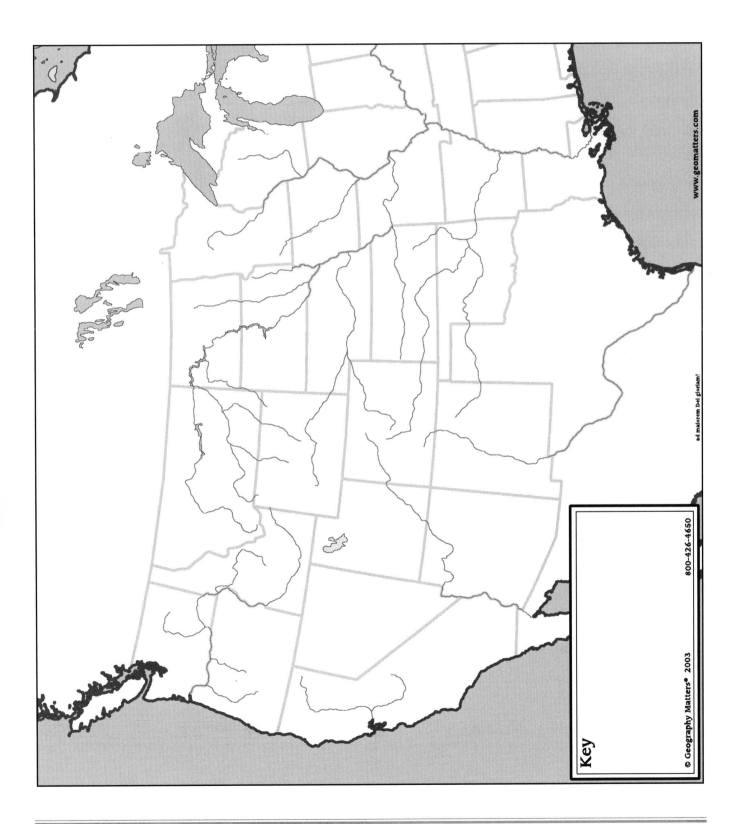

Glossary

acquisition - something acquired or added; something gotten or gained.

adjective - a word that modifies a noun.

background - the part of a scene or picture that is or seems to be toward the back; the surroundings, especially those behind something and providing harmony or contrast.

botany - the branch of biology that studies plants, their life, structure, growth, classification, etc.

cartography - the art or work of making map or charts.

character sketch - a short piece of writing describing a person, especially in terms of personality traits and behavior patterns.

composition - an arrangement of the parts of a work of art so as to form a unified, harmonious whole.

concrete poetry - produces a composition with visual as well as poetic meaning.

cool colors - blue, green, and purple.

depth - showing distance in a picture through using perspective.

descriptive paragraph - a paragraph that describes something; either an object, a person, or a scene.

diplomacy - the conducting of relations between nations, as in building up trades, making treaties, etc.

foreground - the part of a scene, landscape, etc. nearest, or represented in perspective as nearest, to the viewer.

gradient - the blending of shades from light to dark or from one color to another.

habitat - the region where a plant or animal naturally grows or lives.

hot colors - red, orange, and yellow.

implied grid - use of one portion of an object to estimate the size of the whole object.

implied texture - the illusion of texture; resulting from the artist's technique.

landscape - a picture representing a section of natural, inland scenery, as of prairie, woodland, mountains, etc.

monochromatic - using one color or shades of one color.

naturalist - a person who studies nature, especially by direct observation of animals and plants.

negative space - areas around and behind the objects in a drawing; may also be referred to as the background; helps define the subject.

negotiation - a conferring, discussing, or bargaining to reach agreement.

nib - the point of a pen or pencil; the sharpened end of a quill pen.

one-point perspective - a drawing where everything get smaller towards one vanishing point; all horizontal lines are horizontal, all vertical lines are vertical; all other lines meet at the vanishing point.

pattern - a repeated design.

portrait - a representation of a person, especially of the face, drawn, painted, photographed, or sculpted.

positive space - area occupied by the main subjects of the work; the shapes of the objects.

rhythm - in art, a repeating of elements in a picture to give the look and feel of movement.

scale - the proportion or ratio of the relationship between the sizes of objects in a map, model, drawing, etc. to the thing that it represents.

scenery - the general appearance of a place; features of a landscape.

shading - the representation of light or shade in a picture.

shadow - the representation of shadow and shade in a picture.

still life - a grouping of inanimate objects, used as subjects for a picture.

stippling - painting, drawing, engraving, or applying in small points or dots rather than in lines or solid areas.

symbol - something representing something else.

texture - the tactile surface quality of a work of art, resulting from the artist's technique.

topography - the science of drawing on maps and charts or otherwise representing the surface features of a region of the earth, including its relief and rivers, lakes, etc. and such man-made features as canals, bridges, roads, etc.

two-point perspective - a type of linear perspective, where the lines of an object connect with two vanishing points; all vertical lines are vertical; all other lines meet at the vanishing points.

value - the relative lightness or darkness of a drawing or of the color on a drawing.

vanishing point - the point where parallel lines receding from the observer seem to come together.

visionary - a person of strong and creative imaginative power who often has the ability to inspire others.

zoology - the branch of biology that deals with animals, their life, structure, growth, classification, etc.

INTERNET FAVORITES

Please note: Websites can be taken offline at any time. These were live sites at the time of publication.

Animals discovered by Lewis and Clark:

http://encarta.msn.com/media_461519492/Grizzly_Bear_Fishing.html

http://encarta.msn.com/media_461517731/Gray_Wolf.html

http://encarta.msn.com/media_461517556/Coyote.html

http://encarta.msn.com/media_461514788_761556073_-1_1/Prairie_Dog.html

Plants discovered by Lewis and Clark:

http://www.nps.gov/archive/jeff/LewisClark2/TheJourney/PlantLife/PlantLife.htm

Clark's nutcracker:

http://www.photohome.com/photos/animal-pictures/birds/clarks-nutcracker-1.html

http://www.photohome.com/photos/animal-pictures/birds/clarks-nutcracker-2.html

Lewis' woodpecker:

http://www.mbr-pwrc.usgs.gov/id/framlst/i4080id.html

http://birds.cornell.edu/bfl/speciesaccts/lewwoo.html

Westslope cutthroat trout:

http://www.sierraclub.org/lewisandclark/species/trout.asp

http://en.wikipedia.org/wiki/Cutthroat_trout

Important web sites covering this great adventure:

www.pbs.org/lewisandclark

www.lewis-clark.org

www.nationalgeographic.com/lewisandclark/

Index

Trail Guide to Geography Series -
by Cindy Wiggers

Three books in the *Trail Guide to ...Geography* series include U.S., World, and Bible geography. Each book provides clear directions and assignment choices to encourage self-directed learning as students create their own personal geography notebooks. Daily atlas drills, mapping activities, and various weekly assignment choices address learning styles in a way that has kids asking for more! Use each book over several years by choosing more difficult activities as students grow older.

Trail Guide features:
• Weekly lesson plans – for 36 weeks
• 5-minute daily atlas drills (2 questions/day, four days/week)
• 3 levels of difficulty – all ages participate together
• Weekly mapping assignments
• A variety of weekly research and hands-on activity choices

Student Notebooks are available on CD-ROM

Trail Guide Levels
The *Trail Guide* Levels are just a guide. Select a level according to student ability, and match level with the appropriate atlas or student notebook.

• Primary: grades 2–4
• Intermediate: grades 5–7
• Secondary: grades 8–12
All 3 levels in each book!

Note: Primary is ideal for independent 4th graders. Second and third graders will need plenty of guidance. If your oldest is 2nd–3rd grade range, please consider *Galloping the Globe* or *Cantering the Country* first.

Trail Guide to U.S. Geography
Grades 2 - 12

"The *Trail Guide to U.S. Geography* provides lots of guidance while allowing for (and encouraging) flexibility and this is just the balance most homeschool moms need! The manual is easy to navigate and I am very impressed with how thoroughly material is covered. This resource is destined to be a favorite with homeschool families for years to come!"
–Cindy Prechtel, homeschoolingfromtheheart.com
Paperback, 144 pages, $18.95

Trail Guide to World Geography
Grades 2 - 12

"We have the *Trail Guide to World Geography* and **love** it!! We are using it again this year just for the questions... I will never sell this guide!! I am looking forward to doing the U.S. one next year."
–Shannon, OK
Paperback, 128 pages, $18.95

Trail Guide to Bible Geography
Grades 2 - 12

"Here is another winner from Geography Matters! *Trail Guide to Bible Geography* is multi-faceted, user-friendly, and suited to a wide range of ages and abilities."
–Jean Hall, Eclectic Homeschool Association
Paperback, 128 pages, $18.95

Galloping the Globe
Grades K - 4
by Loreé Pettit and Dari Mullins

"If you've got kindergarten through fourth grade students, and are looking for unit study material for geography, hold on to your hat and get ready for *Galloping the Globe!* Loreé Pettit and Dari Mullins have written this great resource to introduce children to the continents and some of their countries. This book is designed to be completed in one to three years, depending on how much time you spend on each topic. And for each continent, there are suggestions and topics galore."
–Leslie Wyatt, www.homeschoolenrichment.com

Organized by continent, incorporates student notebooking, and covers these topics:
• **Basic Geography** • **History and Biographies** • **Literature** • **Science**
• **Bible** • **Activities** • **Internet Sources** • **Language Arts**
Paperback, 236 pages, $24.95

Cantering the Country
Grades 1–5
by Loreé Pettit and Dari Mullins

Saddle up your horses and strap on your thinking caps. Learning geography is an adventure. From the authors who brought you *Galloping the Globe,* you'll love its U.S. counterpart, *Cantering the Country.* This unit study teaches a wide range of academic and spiritual disciplines using the geography of the U.S. as a starting point. With this course, you won't have to put aside one subject to make time for another. They're all connected! This comprehensive unit study takes up to three years to complete and includes all subjects except math and spelling. Incorporates student notebooking and covers these topics:
• **U.S. Geography** • **Character** • **Science** • **Language Arts**
• **Activities** • **Literature** • **Civics** • **History and Biographies**
• **Internet Sources** • **Bible**

In addition to the 250+ page book, you will receive a CD-ROM packed full of reproducible outline maps and activities. Dust off your atlas and get ready to explore America! Paperback, 254 pages, $39.95

The Ultimate Geography and Timeline Guide
by Maggie Hogan and Cindy Wiggers

Grades K - 12

Learn how to construct timelines, establish student notebooks, teach geography through literature, and integrate science with activities on volcanoes, archaeology, and other subjects. Use the complete multi-level geography course for middle and high school students. Includes timeline figures, reproducible outline maps, and many more reproducible pages. Use for all students kindergarten through high school. Paperback, 353 pages, $34.95

- 18 Reproducible Outline Maps
- Teaching Tips
- Planning Charts
- Over 150 Reproducible Pages
- Over 300 Timeline Figures
- Lesson Plans
- Scope and Sequence
- Flash Cards
- Games

Mark-It Timeline of History
There's hardly no better way to keep history in perspective than creating a timeline in tandem with your history studies. This poster is just the tool to do so. Write or draw images of events as they are studied, or attach timeline figures to aid student understanding and comprehension of the topic at hand. 23" x 34". Laminated, $10.95, Paper (folded), $5.95

Timeline Figures on CD-ROM

Kids love the look of their timelines when they add color and variety. Students can draw on their timeline, write events and dates, and add timeline figures. We've created two different sets of color timeline figures that are ready to print from any computer. There are over 350 figures in each set plus templates to create your own. Our figures are appealing in style, simple to use, and include color-coding and icons to aid memory. Available with biblical events and general world events.

Historical Timeline Figures CD-ROM

Includes **bonus** "Who Am I?" game cards. Select from 2 sets of figures, one with borders and one without - both included on this disk. Figures from c. 3800 b.c. - 2001, CD-ROM (Mac & Windows Compatible), $24.95

Bible Timeline Figures CD-ROM

Includes figures for all major Bible events and characters, plus a bonus section of story-line figures that encourage youngsters to retell Bible stories in their own words. CD-ROM (Mac & Windows Compatible), $24.95

Adventures of Munford

by Jamie Aramini, illustrated by Bob Drost

Join Munford the water molecule on his adventures through time and experience real historical events through his eyes. Titles available at the time of this printing (with more to come) include: *Munford Meets Lewis and Clark, Munford at the Klondike Gold Rush, Munford at the Birth of Independence*. For kids of all ages, reading level: grades 3 and up. Paperback, 170 pages, $8.95

Eat Your Way Through the USA
by Loreé Pettit

Taste your way around the U.S.A. without leaving your own dining room table! Each state has its unique geographical features, culinary specialities, and agricultural products. These influence both the ingredients that go into a recipe and the way food is prepared. Compliment your geography lesson and tantalize your tastebuds at the same time with this outstanding cookbook.

This cookbook includes a full meal of easy to follow recipes from each state. Recipes are easy to follow. Though they aren't written at a child's level, it's easy to include your students in the preparation of these dishes. Cooking together provides life skills and is a source of bonding and pride. More than just a cookbook, it is a taste buds-on approach to geography. Spiral bound, 118 pages, $14.95

Eat Your Way Around the World
by Jamie Aramini

Get out the sombrero for your Mexican fiesta! Chinese egg rolls... corn pancakes from Venezuela...fried plantains from Nigeria. All this, and more, is yours when you take your family on a whirlwind tour of over thirty countries in this unique international cookbook. Includes a full meal of recipes from each country. Recipes are easy to follow, and ingredients are readily available. Jam-packed with delicious dinners, divine drinks, and delectable desserts, this book is sure to please.

The entire family will be fascinated with tidbits of culture provided for each country including: Etiquette hints, Food Profiles, and Culture a la Carté. For more zest, add an activity and violà, create a memorable learning experience that will last for years to come. Some activities include: Food Journal, Passport, and World Travel Night. Spiral bound, 120 pages, $14.95

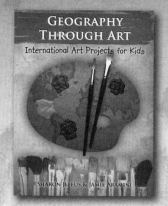

Geography Through Art

by Sharon Jeffus and Jamie Aramini

Geography Through Art is the ultimate book of international art projects. Join your children on an artistic journey to more than twenty-five countries spanning six continents (includes over a dozen United States projects). Previously published by Visual Manna as *Teaching Geography Through Art*, Geography Matters has added a number of enhancements and practical changes to this fascinating art book. Use this book as an exciting way to supplement any study of geography, history, or social studies. You'll find yourself reaching for this indispensable guide again and again to delight and engage students in learning about geography through the culture and art of peoples around the world. Paperback, 190 pages, $19.95

Lewis & Clark - Hands On

Art and English Activities

by Sharon Jeffus

Follow the experiences of Meriwether Lewis and William Clark with hands on art and writing projects associated with journal entries made during the Corps of Discovery Expedition. Ideal for adding interest to any Lewis and Clark study or to teach drawing and journaling. Includes profiles of American artists, step by step drawing instructions, actual journal entries, and background information about this famous adventure. Paperback, 80 pages, $12.95

Profiles from History

by Ashley (Strayer) Wiggers

When studying history, a human connection is the most important connection that we can make. In *Profiles from History*, your student will not only learn about twenty famous people – but also why each one is worthy of remembrance. Everyone knows that Benjamin Franklin was a great inventor, but how many realize he was also a great man? He valued helping people more than making money or becoming famous. He refused to patent his popular Franklin stove, so more families could keep their homes warm during the cold, winter months. *Profiles from History* tells stories like this one, stories of greatness and inspiration. Each profile includes fun activities such as crosswords, word search, & timeline usage. Paperback, $14.95

- Reproducible Outline Maps -

Reproducible outline maps have a myriad of uses in the home, school, and office. Uncle Josh's quality digital maps provide opportunities for creative learning at all ages. His maps feature rivers and grid lines where possible, and countries are shown in context with their surroundings. (No map of Germany "floating" in the center of the page, here!) When students use outline maps and see the places they are studying in context they gain a deeper understanding of the subject at hand.

Uncle Josh's Outline Map Book

Take advantage of those spontaneous teaching moments when you have this set of outline maps handy. They are:

- Over 100 reproducible maps
- 15 world regions
- Continents with and without borders
- 25 countries
- Each of the 50 United States
- 8 U.S. regions

Useful for all grades and topics, this is by far one of the best book of reproducible outline maps you'll find. Paperback, 128 pages, $19.95

Uncle Josh's Outline Map Collection CD-ROM

In addition to all maps in *Uncle Josh's Outline Map Book* the CD-Rom includes color, shaded-relief, and labeled maps. Over 260 printable maps plus bonus activities. CD-ROM (Mac & Windows), $26.95

- Large-scale Maps -

Large-scale maps are great for detail labeling and for family or classroom use. Laminated Mark-It maps can be reused for a variety of lessons. Quality digital map art is used for each of the fifteen map titles published and laminated by Geography Matters. Choose from large scale continents, regions, United States, and world maps. US and World available in both outline version and with state, country, and capitals labeled. Ask about our ever expanding library of full, color shaded-relief maps. Paper and laminated, each title available separately or in discounted sets.

Trail Guide to Learning Series

Paths of Exploration
A Complete Curriculum
by Debbie Strayer and Linda Fowler

Wouldn't you love to guide your students in learning HOW to think rather than simply WHAT to think? Imagine working with real books, reading and writing for a reason, and using activities that don't just fill time and paper - but bring points home. Imagine needing little teacher preparation because all lessons are clearly laid out. Imagine your students creating personal notebooks that double as portfolios to show what they have learned. *The Trail Guide to Learning* series does all these things! Now you can teach multiple levels together with tremendous flexibility, all while producing one remarkable result - encouraged students!

The *Trail Guide to Learning* series is based on **proven educational principles** and fully utilizes methods developed by noted author and educator, **Dr. Ruth Beechick**.

Paths of Exploration, the first in this series, covers the following six units in two volumes and includes language skills, science, history, geography, art, and thinking skills:

Volume 1: Columbus, Jamestown, Pilgrims
Volume 2: Daniel Boone, Lewis & Clark, Trails West

Hardback, 816 pages, two volume set, includes CD-ROM with printable games and Student Notebook pages for each grade level. Grades 3-5, adaptable for 2nd and 6th, $150

Volume 1 Volume 2

Required readers and support materials used in *Paths of Exploration*. Lessons in *Paths* tell you exactly what pages to use and when.

Volume 1 Resources
Meet Christopher Columbus by James T. de Kay
Christopher Columbus by Bennie Rhodes
Stories of the Pilgrims by Margaret Pumphrey (2nd Ed. Christian Liberty Press)
Stories of the Pilgrims Answer Key
Squanto, Friend to the Pilgrims by Clyde Robert Bulla
A Lion to Guard Us by Clyde Robert Bulla
Surviving Jamestown by Gail Karwoski
Profiles from History by Ashley Strayer Wiggers
Handbook of Nature Study by Anna Comstock
North American Wildlife Guide published by Reader's Digest
Eat Your Way Around the World by Jamie Aramini
Intermediate World Atlas published by Rand Mc Nally
5" RealEarth® GlobeMap™
Large-Scale U.S. and World Outline Maps by Geography Matters

*Used with both Volume 1 and 2

Volume 2 Resources
Daniel Boone, Frontiersman by Janet and Geoff Benge
Daniel Boone, Young Hunter & Tracker by Augusta Stevenson
Munford Meets Lewis and Clark by Jamie Aramini
Seaman by Gail Karwoski
Trouble for Lucy by Carla Stevens
Johnny Appleseed by David Collins
1911 Boy Scout Handbook
United States History Atlas
Lewis & Clark Hands On by Sharon Jeffus (©2009)
Going West!: Journey on a Wagon Train to Settle a Frontier Town, a Kaleidoscope Kids book

Printable Student Notebook pages and games are on the CD-ROM included in this 2 Volume Set. Pre-printed, three-hole punched Student Notebook pages are also available separately.

Call or visit our website for discount package specials.

Optional Support Resources Available on CD-ROM

Assessments
Coupled with daily observations and interactive discussions and games this disk provides ample material upon which to base an accurate evaluation of student progress. Answer keys included, $24.95.

Light for the Trail Bible Study Supplement
Optional Bible study curriculum that coincides with the 6 units in *Paths of Exploration*. Easy-to-use guide provides daily assignments and helps students make the most important connection of all–the one between their faith and their view of the world around them, $12.95.

Look online now for more information and to view sample pages.

www.geomatters.com/learning_series • 800-426-4650

Learn Art Techniques and Art History Live on the Internet with Sharon Jeffus

Do you have skype on your computer? It is perfect for doing lessons via your own home computer. Art lessons are available for all ages. You can watch the teacher step by step and ask questions as you complete your project. The teacher can see your finished product and give you pointers all in the comfort of your own house.

We offer the following classes:

1. Art techniques and history class:
 Sharon Jeffus teaches a 16 week art class via the internet. Class can be started at any time and are done in 8 week segments. The class includes ancient, Renaissance, Baroque, Impressionism, Expressionism, computer graphic art, etc. This covers all the important master artists in art history. Architecture and sculpting are also included.
2. Art techniques combined with creative writing, 16 weeks, taught by Sharon Jeffus.
3. Eight week drawing class.
4. Classes for ages 4-8 are also offered on an eight week basis.
5. Beginning English taught visually, by Sharon Jeffus.
6. Internet computer graphic class that includes free software download.
 Students learn to draw on the computer and animate their characters.

"Thanks for the info on how to enter Gabrielle's story. She wrote me the sweetest letter for Christmas. I cried..... knowing that at one point and time I could not persuade her to write, it was quite a gift! Very creative. Thanks for giving her tools to feel empowered to do that."
- Tami

Feature Products

• *Visual Manna One Complete Curriculum* now has a unit study edition to it. Teach all your core subjects around an art lesson. You get an update included with package.

• *Artsy Animals* Books are available and internet parties offered around different themes.

Following is a review of *Artsy Animals* by the well known website Alphabet Soup:

Something New!!
We have a great new book for our book drawing this month! Sharon Jeffus sent me a copy of her delightful book, *Artsy Animals, Learn to Read*. This book is wonderful for children to learn interesting facts about animals along with their study of reading. It can be used as an excellent supplement to a reading program. Fine motor skills are enhanced by drawing activities!

For FREE lessons and detailed descriptions of all of our classes and products, go to:
visualmanna.com.

Visual Manna • P.O. Box 553 Salem MO 65560 • 1-573-729-2100

About the Author

Sharon Jeffus has a B.S.S.E. in Art Education from John Brown University and earned her certification to teach English from the University of Arkansas. She studied painting at Metropolitan in Denver and sculpting at Southern Illinois University.

Sharon taught in the public schools for ten years in Arkansas, Oklahoma, and Missouri. She taught Intensive English as an adjunct lecturer at the University of Missouri-Rolla; has given presentations on teaching art to college classes at Azusa Pacific University and Columbia College; taught in a Christian school in Branson, Missouri; and has given presentations to the Associated Christian Schools International Conventions across America.

She left the public school system to write books, travel, and homeschool her two sons. She has written over twenty books and owns the internationally known company Visual Manna which she founded with her late husband Richard. Sharon developed the Visual Manna teaching method where art is integrated with art appreciation, techniques, vocabulary, and core subjects. She is a regular writer for *The Old Schoolhouse* magazine and has written for a number of other educational resources. She has authored an Indian Arts and Crafts program that was rated outstanding by the Bureau of Indian Affairs, and her materials are recommended by Montessori.